Chris Hart

Cartooning
THE ULTIMATE CHARACTER DESIGN BOOK

Chris Hart

Cartooning

THE ULTIMATE

DESIGN

CHARACTER BOOK

Chris Hart Books

sixth&spring books

Chris Hart Books

161 Avenue of the Americas
New York, NY 10013

Editorial Director
ELAINE SILVERSTEIN

Book Division Manager
ERICA SMITH

Senior Editor
MICHELLE BREDESON

Art Director
DIANE LAMPHRON

Associate Art Director
SHEENA T. PAUL

Copy Editor
KRISTINA SIGLER

Book Editor
DANIEL FINGEROFF

Color
ROMULO FAJARDO, JR.

President
ART JOINNIDES

Vice President, Publisher
TRISHA MALCOLM

Production Manager
DAVID JOINNIDES

Creative Director
JOE VIOR

Library of Congress Control Number: 2007907249

ISBN 978-1-933027-42-5

Manufactured in China

9 1 0

First Edition

I'd like to thank Art Joinnides for making this book possible. Also, Trisha Malcolm, Elaine Silverstein and many other people at Soho Publishing, who are all dedicated to the belief that there aren't nearly enough snow days during the school year.

FOR FRANCESCA

chrishartbooks.com

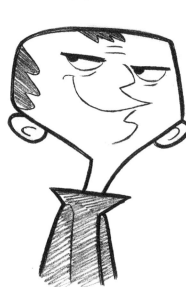

CONTENTS

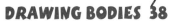

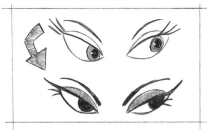

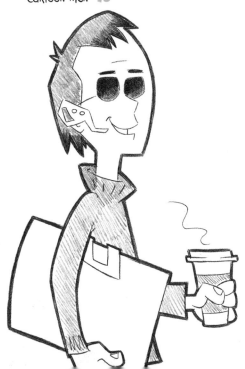

CONTENTS

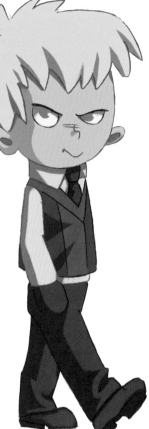

The Cast of Characters

GReat caRtooN CHaRacteRs DoN't JuSt HaPPeN.

They are carefully designed to fit specific types—the bratty sibling, the ditsy suburbanite, the evil spy. Readers instantly recognize these types because cartoonists combines specific, well-known physical attributes to create them.

How do we come up with the inspiration for great characters? It's a well-guarded secret, but I'm going to break the Cartoonist's Code of Silence and reveal it to you. We look for inspiration to the weird and wacky neighborhoods where all of the quirky characters already exist.

Goofy neighborhoods just ooze great characters. And each neighborhood is unique: a fast-talking city character walks and dresses a lot differently than one from the sticks. What about the prep-school kid from Connecticut who meets his cousin from Brooklyn for the first time? You can see the comic scenes start to play out in your mind, can't you? And don't forget that mother of all cartoon neighborhoods: the suburb.

This book covers all these recognizable types, plus a lot more. I've designed it to be helpful to beginners who want to learn the most current style of cartooning. But it's also a wonderful resource for experienced artists who enjoy developing new and original characters.

The first half of this book takes you through the basics of cartooning with a emphasis on character design, so you start out learning to draw eye-catching characters. The second half shows you specific character types and demonstrates precisely how to create them. We'll go neighborhood-by-neighborhood to find all of today's most popular cartoon character types: from suburbanites to big city dwellers, from the country-club blue-blood set to the glitterati of Hollywood and Beverly Hills.

Character design is a skill you can learn quickly. However, you need character-driven instruction to do it. In this book you'll get extensively illustrated clues and pointers specifically targeted to show you exactly how to create character types. The style we'll focus on is ultra-current and on-target for today's cartoonist—which is what you are. So pick up a pencil and hop on board!

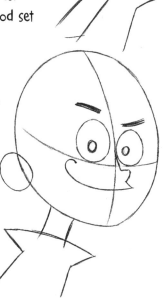

The Character Design Lab

Before we go headlong into creating all the different types of cartoon characters based on different neighborhoods, locations and occupations, let's take a look at some character-driven cartooning basics.

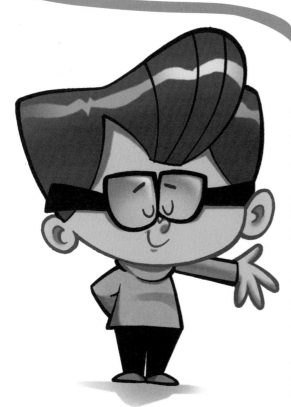

THE AMAZING PENCIL

Take a moment to look over the most versatile art instrument you'll ever use: **the pencil.** It can create many shades of darkness and many types of lines in a variety of thicknesses—and we're going to end up using all of them in this book.

A trip to your local art supply store will show you that there are many types of pencils with all sorts of letters and numbers on them. But the type cartoonists most often use is the HB, which is the same as the ordinary #2 pencil that you probably have lying around the house. And now, let's see what the not-so-humble pencil has to offer.

CARTOON SHADING TECHNIQUES

Here are some of the more popular methods cartoonists use to indicate shadow, or dark patches, on people and things.

BLOCKED OUT
Press down hard, you're going for dark shadows

SLIGHTLY STREAKED
Just a touch of shadow

TOTAL CROSS-HATCHING
An older technique, used infrequently

DARK-TO-LIGHT
An appealing graduated look

PARTIAL CROSS-HATCHING
Usually used for corners and crevices

ZIG-ZAGGING
Gives a bold, energetic look

TYPES OF LINES

The **classic line** is the most versatile. It is used for any type of character or cartooning style. The very dark **retro line** is best for simplified, angular, high-energy characters. The **sketch line** is best for the creative process, when you are first inventing your characters. Then use one of the other two lines to trace over the sketch.

CLASSIC LINE **RETRO LINE** **SKETCH LINE**

MANY SHADES FROM A SINGLE PENCIL

By simply pressing harder or lighter on your pencil, you can get a wide variety of shades.

White

Light Gray

Medium Gray

Dark Gray

Black

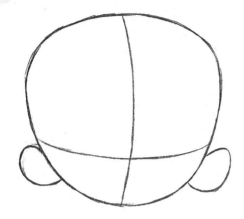

The Language of Character Design

Let's dive right in. There are important traits and visual cues that make each character type unique. For example, you won't find a cartoon hero with a small chin. Just won't happen. All heroes have strong chins. So we're first going to familiarize ourselves with the tools cartoonists use to build recognizable characters. This is the language of character design.

THE FOUR CLASSIC HEAD STYLES

The four most popular, and most commonly seen, types of cartoon character types, based on age and gender, are:

- ● KIDS
- ● TWEENS & TEENAGERS
- ● MOMS & FEMALE ADULTS
- ● DADS & MALE ADULTS

Head shape is a circle with a carve-out

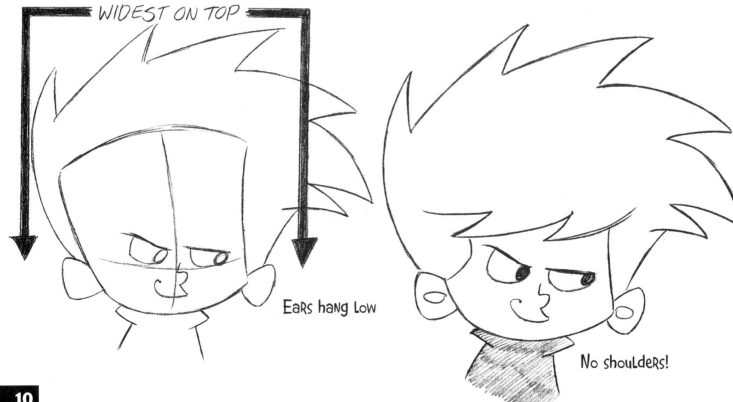

WIDEST ON TOP

Ears hang low

No shoulders!

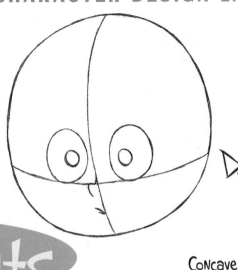

Tiny Tyrants

Cartoon youngsters have huge heads that are essentially circles with a section cut out. ALL of their features must appear very low on the face. As a result, they've got a lot of forehead. The ears hang low on the head. As a rule, kids have tiny, upturned noses and BIG eyes. Tons of hair. Tiny neck or no neck—you can even eliminate it entirely. Sloping shoulders. No muscles yet!

Concave forehead

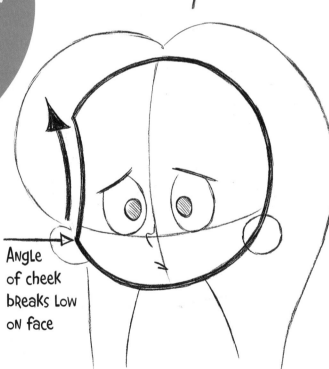

Angle of cheek breaks low on face

Big hair!

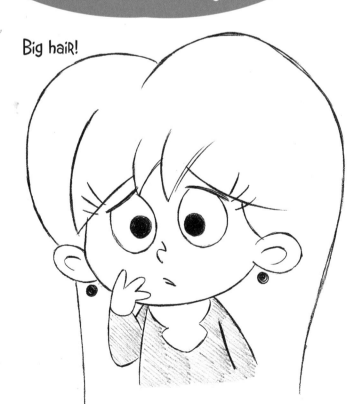

Big almond-shaped eyes

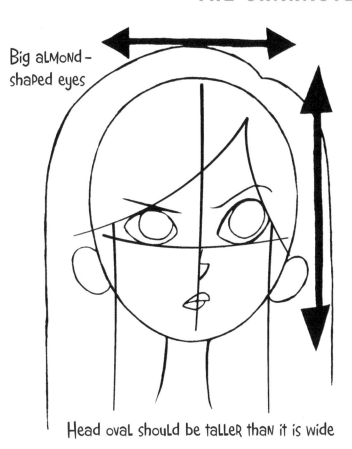

Head oval should be taller than it is wide

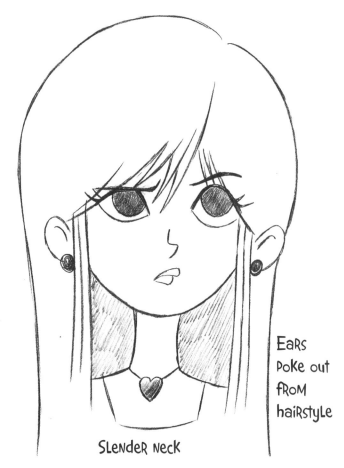

Ears poke out from hairstyle

Slender neck

TEENS & TWEENS

For teens and tweens, think ovals! The teen's head has grown longer than the youngster's, and the features have moved slightly up the face. However, there should still be a lot of forehead, which is typical of young characters. Teens have big, bright eyes and a more self-conscious hairstyle, because, at this age, hair defines their personality. Teen boys should have floppy hair, as if it needs combing. Teen girls tend to wear their hair long. In general, the older the female character, the shorter the hairstyle.

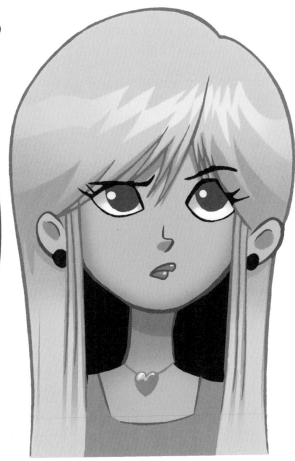

Big forehead area

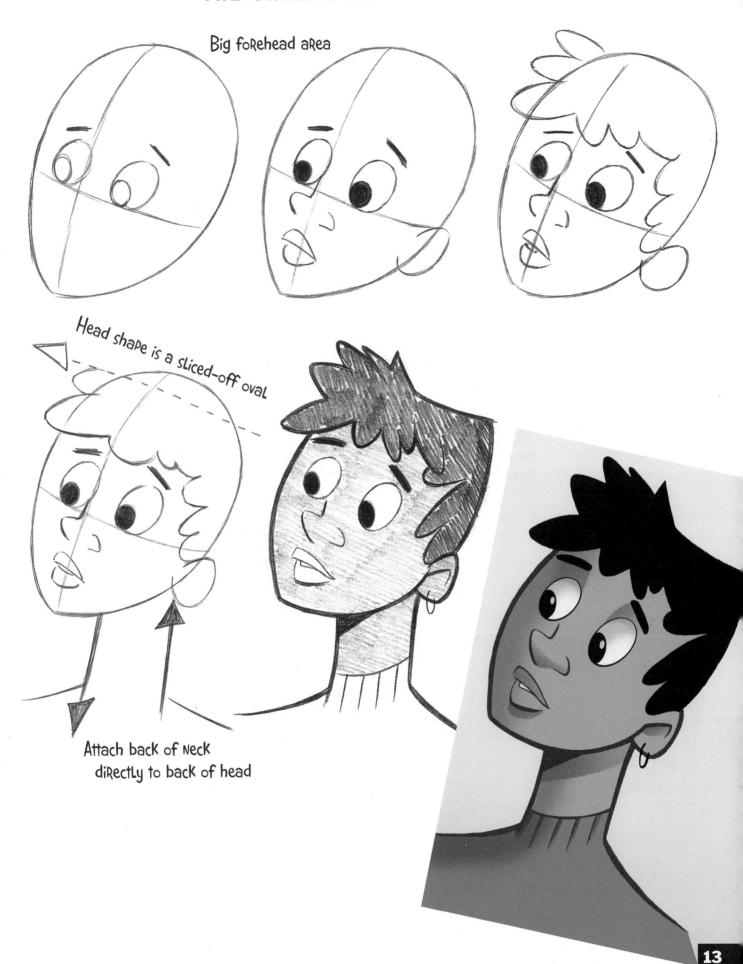

Head shape is a sliced-off oval

Attach back of neck
directly to back of head

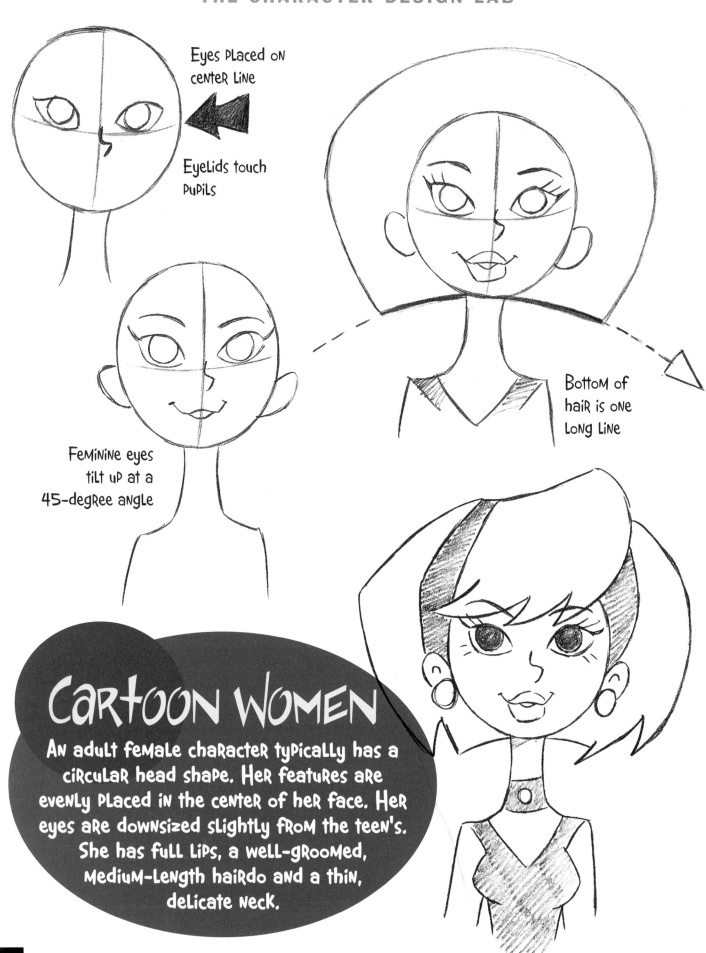

Eyes placed on center line

Eyelids touch pupils

Feminine eyes tilt up at a 45-degree angle

Bottom of hair is one long line

Cartoon Women

An adult female character typically has a circular head shape. Her features are evenly placed in the center of her face. Her eyes are downsized slightly from the teen's. She has full lips, a well-groomed, medium-length hairdo and a thin, delicate neck.

Cartoon Men

On adult male characters, the shape of the head has lots of flat planes. Often he wears glasses, which cluster his features in the middle of his face. Note the jaunty chin!

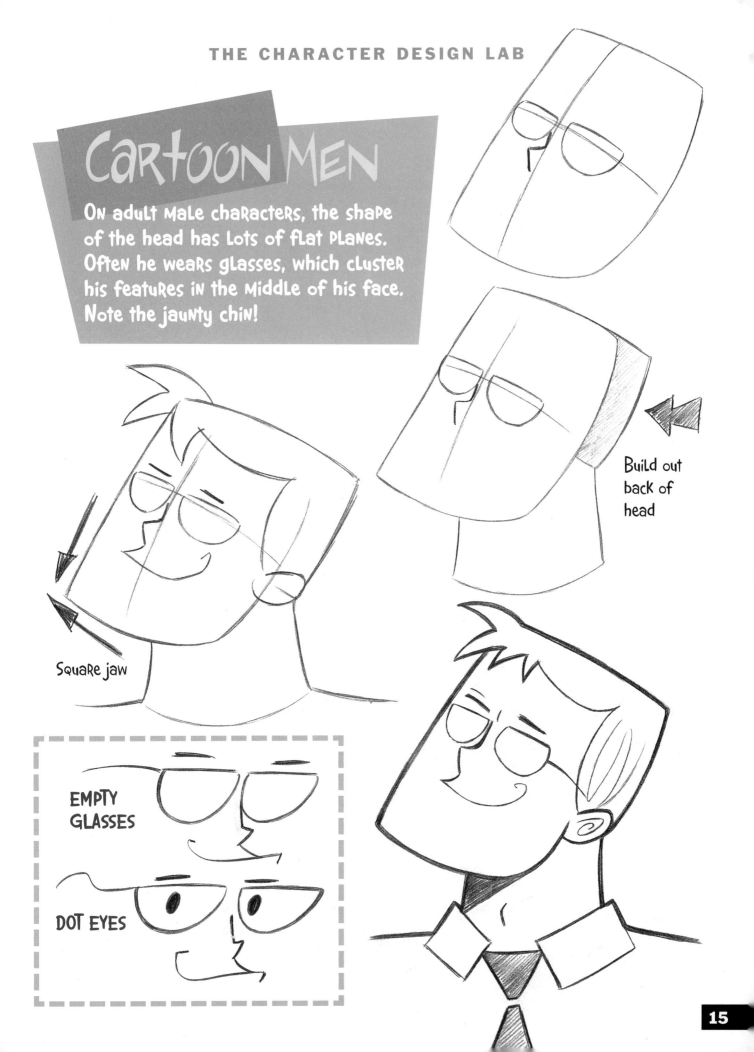

Build out back of head

Square jaw

EMPTY GLASSES

DOT EYES

Drawing the Head

HEAD SHAPES AND CLASSIC CHARACTER TYPES

We all assume that the shape and size of a person's build says something about his or her personality. An athletic build, a slouching posture or a couch-potato physique: each indicates a different type of character. As cartoonists, we use these cues when creating a character's face as well: a blockhead must be a jock; a huge forehead houses a genius's massive brain. Your characters will be a lot more effective if you select a head shape that matches each one's personality.

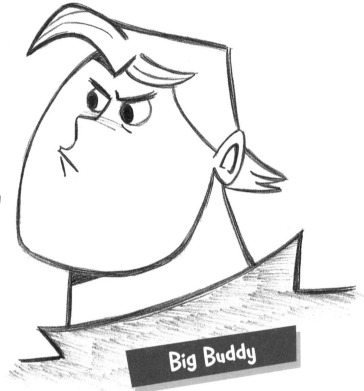

Big Buddy

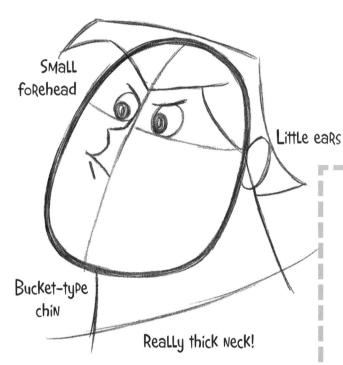

Small forehead

Little ears

Bucket-type chin

Really thick neck!

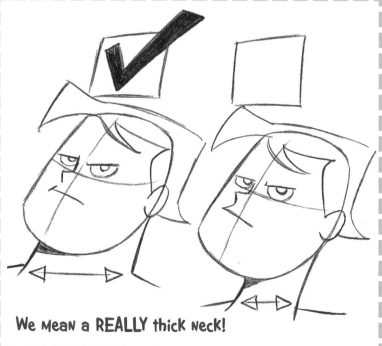

We mean a REALLY thick neck!

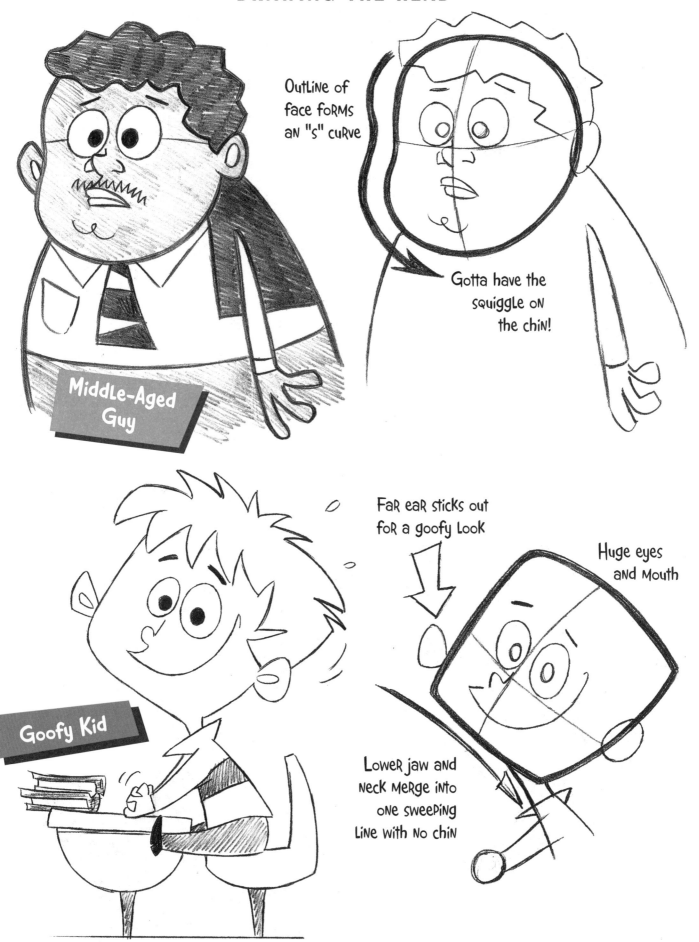

Outline of face forms an "s" curve

Gotta have the squiggle on the chin!

Middle-Aged Guy

Far ear sticks out for a goofy look

Huge eyes and mouth

Goofy Kid

Lower jaw and neck merge into one sweeping line with no chin

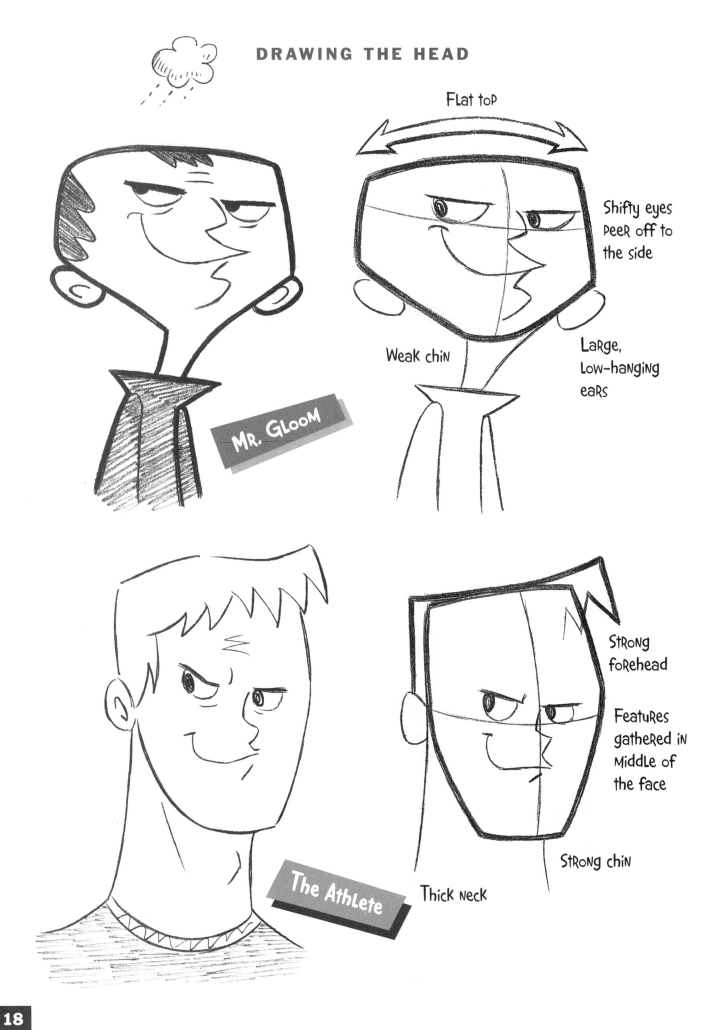

Flat top

Shifty eyes PeeR off to the side

Weak chin

Large, Low-hanging eaRs

MR. GLooM

STRoNG foRehead

Features gathered iN Middle of the face

STRoNG chiN

The AthLete

Thick Neck

18

Stylish Gal

Swollen
upper lip

Almond eyes
with overhanging
eyelids

Pointed chin, not
a rounded
egg-shape head

DRAWING the Head FROM DifferENt AngLes

One of the things that MaRKs a seRious caRtooNist is the ability to dRaw a chaRacteR iN aNy positioN, that is to say, fRom aNy aNgLe. Without this skiLL, aN aRtist couLd NeveR dRaw a coMic stRip, coMic book oR aNiMated TV show oR Movie, because the chaRacteRs couLd Not be Repeated iN diffeReNt positioNs. To RecReate the Look of a chaRacteR, it's Not the featuRes you have to RepRoduce pRecisely. It's the outLiNe of the head aNd the positioN of the ceNteR LiNes (the veRticaL aNd hoRizoNtaL LiNes that aRtists dRaw oN theiR iNitiaL sketches). These aRe youR guidePosts. They dictate wheRe the featuRes faLL iN pLace, aNd that's the Key to cReatiNg a coNviNciNg dRawiNg.

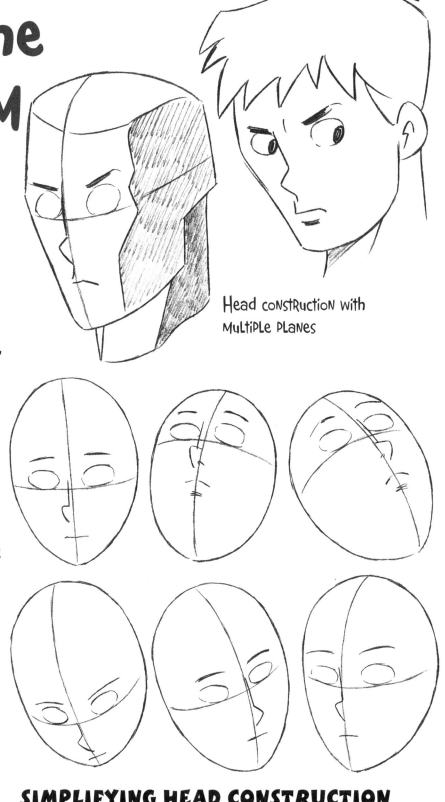

Head coNstRuctioN with MuLtipLe pLaNes

SIMPLIFYING HEAD CONSTRUCTION

You wiLL be abLe to positioN the head at diffeReNt aNgLes Much moRe easiLy if you fiRst thiNk of it as a siMpLe egg shape. Then, caRve moRe pLaNes out of the egg. The RuLe of thuMb is: WoRK fRom the geNeRaL egg shape to the specific iNdividuaL head.

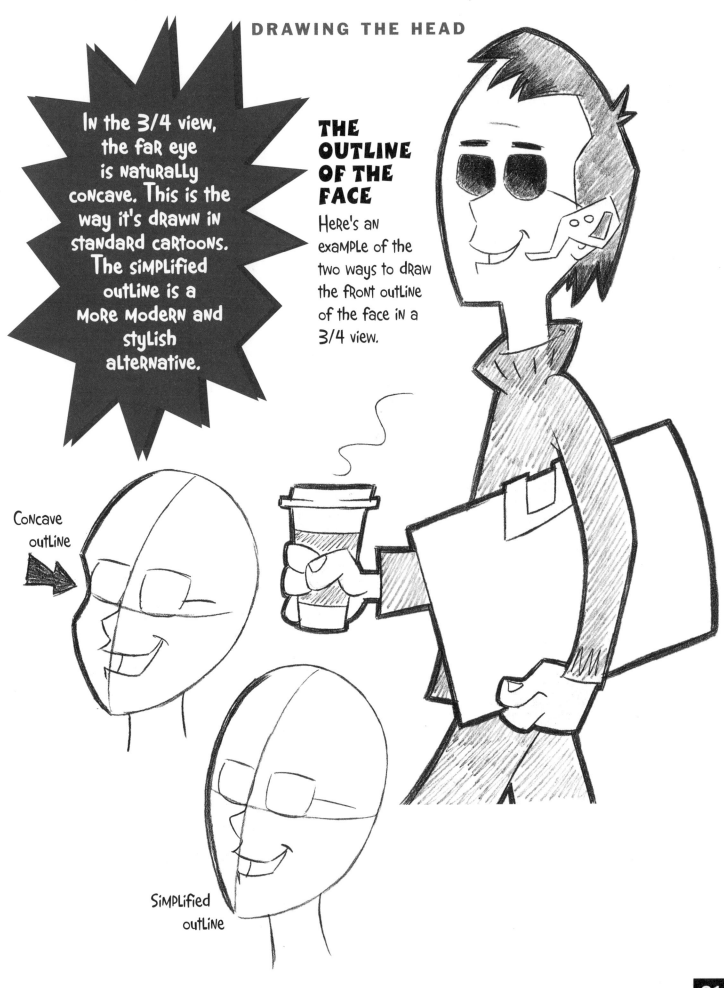

In the 3/4 view, the far eye is naturally concave. This is the way it's drawn in standard cartoons. The simplified outline is a more modern and stylish alternative.

THE OUTLINE OF THE FACE

Here's an example of the two ways to draw the front outline of the face in a 3/4 view.

Concave outline

Simplified outline

Drawing Expressive Eyes

Funny expressions are built on funny eyes. I'll show you the specific techniques you need to make the eyes funny, no matter what the character is thinking, saying or doing.

THE THREE BASIC EYE SHAPES

There are three basic shapes for cartoon eyes: **tall** (up and down); **wide** (side to side); and almond-shaped (usually female), which are drawn on a diagonal.

MAKING GOOD EXPRESSIONS EVEN BETTER

We all have some idea of how to draw basic expressions like angry eyes, happy eyes, and so on. But to take your drawing to the next level, you've got to add a little more spice. Simply drawing two eyebrows pointed downward to indicate anger or upward for joy won't do the trick. Let's see how we can exaggerate expressions to make them funnier.

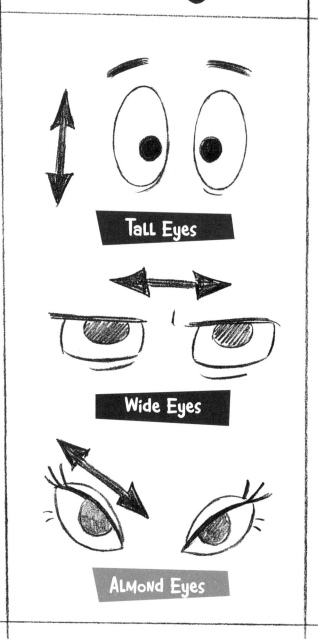

Tall Eyes

Wide Eyes

Almond Eyes

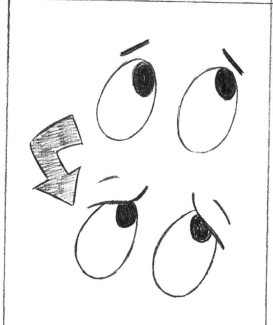

◀ **ORDINARY WORRIED EYES**

◀ **EXAGGERATED VERSION**
Eyebrows curve down slightly over the eyes, acting like muscles. Secondary wrinkles emphasize the worried effect.

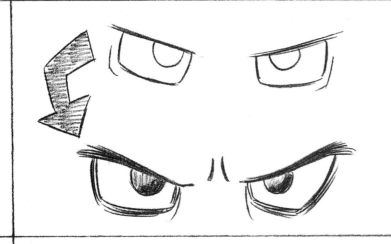

◀ **ORDINARY ANGRY EYES**

◀ **EXAGGERATED VERSION**
Heavier eyebrows, creases in forehead, rings underneath eyes

ORDINARY STUNNED EYES ▶

EXAGGERATED VERSION ▶
White shine in center of pupils, motion lines around sides of eyes, worry lines under eyes

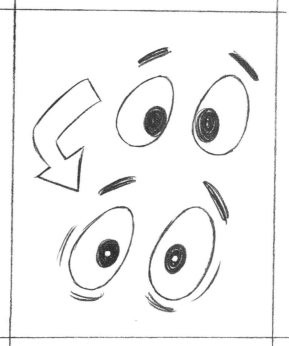

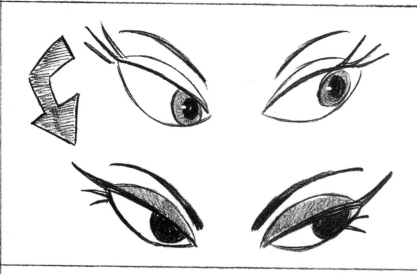

◀ **ORDINARY SEDUCTIVE EYES**

◀ **EXAGGERATED VERSION**
Eyelids blocked in with heavy makeup (indicated by pencil shadowing), eyebrows thickened, fuller eyelashes

Drawing Expressions

While it's good practice to draw eyes by themselves, eventually you're going to have to draw them as part of a face and head. After all, eyes are just part of how a character is depicted. You have to understand how eyes work in concert with all of a character's other features. For our model, I've chosen our mischievous 12-year-old pal, whom I'll call Brandon. I've picked him because he's drawn using a simple construction with the eyes near the center of his head.

SLY EXPRESSION

Most eye expressions are supported by the expression of the mouth. (We'll get to mouths in a few pages.) For the sly expression, Brandon's eyelids rest directly on top of his pupils. One eyebrow is raised in curiosity, while the other points mischievously down.

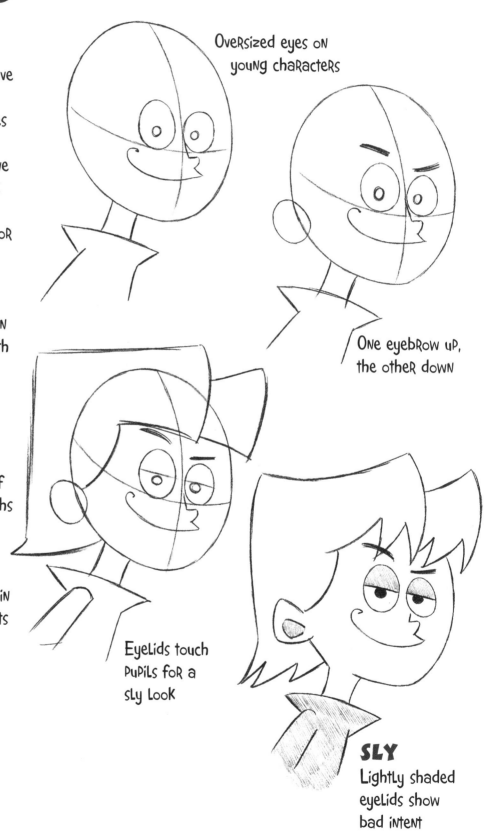

Oversized eyes on young characters

One eyebrow up, the other down

Eyelids touch pupils for a sly look

SLY
Lightly shaded eyelids show bad intent

EYE EXPRESSIONS

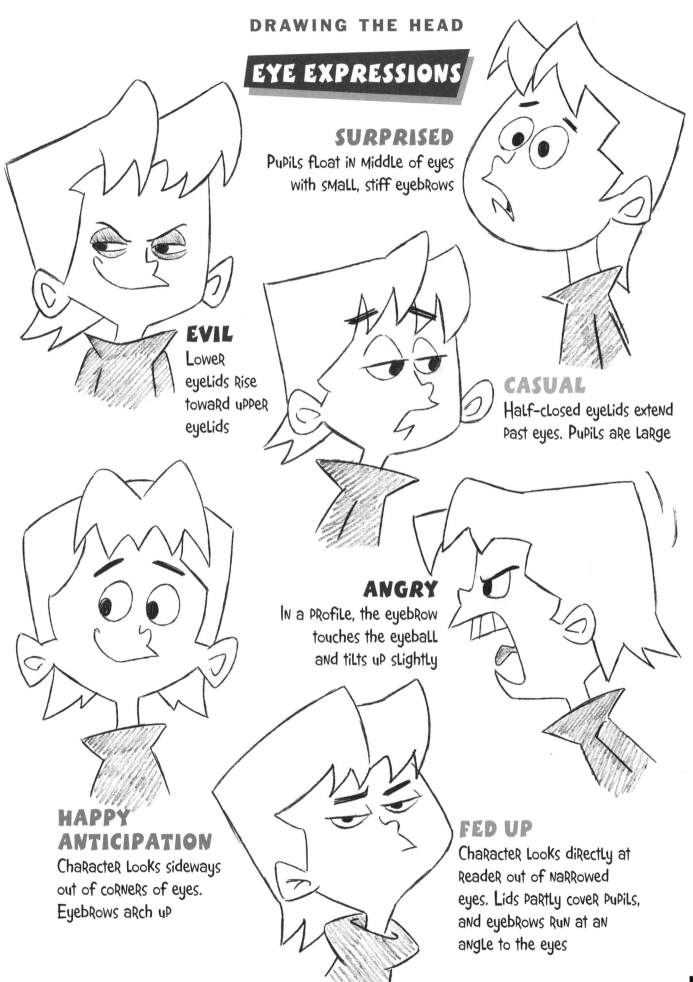

SURPRISED
Pupils float in middle of eyes with small, stiff eyebrows

EVIL
Lower eyelids rise toward upper eyelids

CASUAL
Half-closed eyelids extend past eyes. Pupils are large

ANGRY
In a profile, the eyebrow touches the eyeball and tilts up slightly

HAPPY ANTICIPATION
Character looks sideways out of corners of eyes. Eyebrows arch up

FED UP
Character looks directly at reader out of narrowed eyes. Lids partly cover pupils, and eyebrows run at an angle to the eyes

Noses

Male Noses

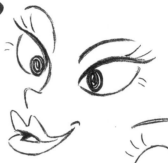

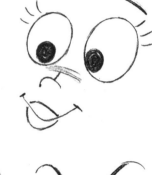

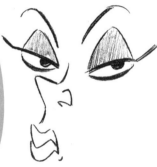

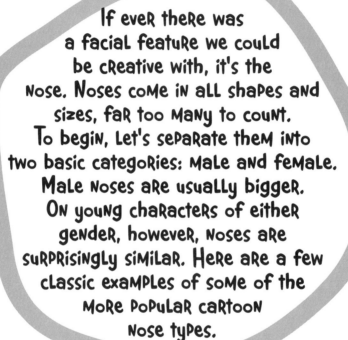

If ever there was a facial feature we could be creative with, it's the nose. Noses come in all shapes and sizes, far too many to count. To begin, let's separate them into two basic categories: male and female. Male noses are usually bigger. On young characters of either gender, however, noses are surprisingly similar. Here are a few classic examples of some of the more popular cartoon nose types.

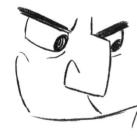

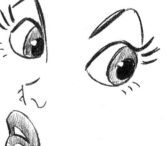

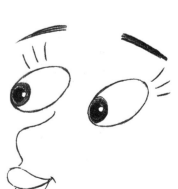

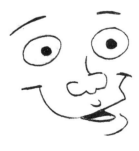

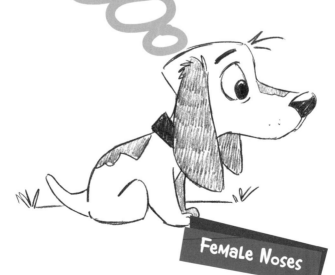

Female Noses

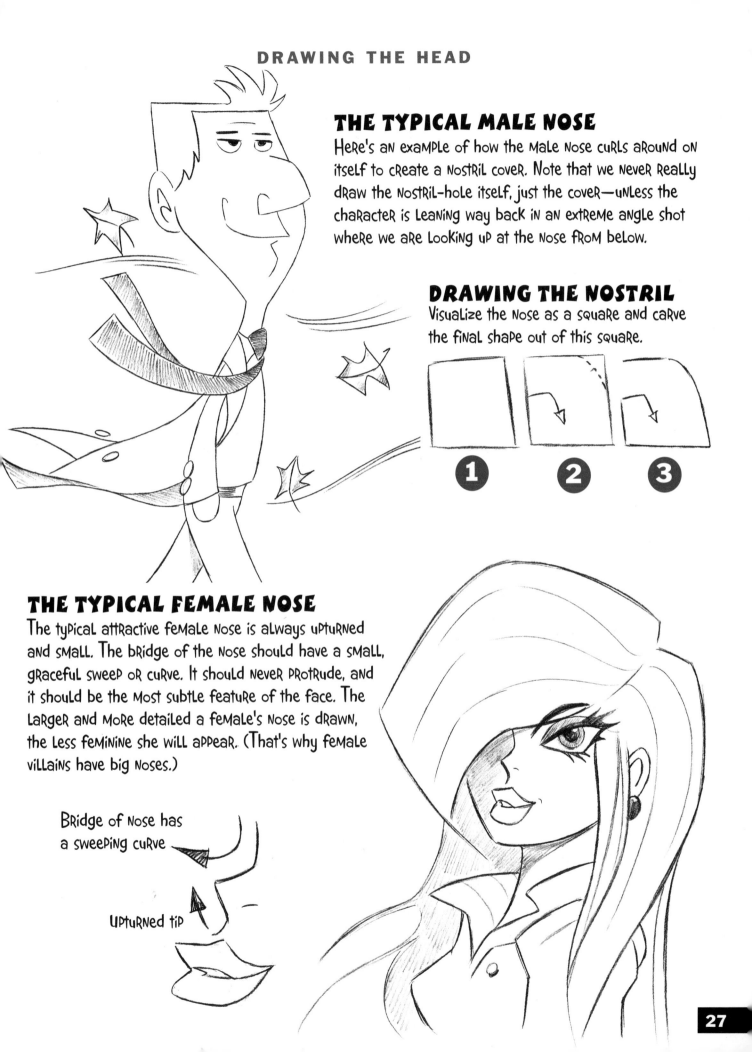

THE TYPICAL MALE NOSE

Here's an example of how the male nose curls around on itself to create a nostril cover. Note that we never really draw the nostril-hole itself, just the cover—unless the character is leaning way back in an extreme angle shot where we are looking up at the nose from below.

DRAWING THE NOSTRIL

Visualize the nose as a square and carve the final shape out of this square.

1 **2** **3**

THE TYPICAL FEMALE NOSE

The typical attractive female nose is always upturned and small. The bridge of the nose should have a small, graceful sweep or curve. It should never protrude, and it should be the most subtle feature of the face. The larger and more detailed a female's nose is drawn, the less feminine she will appear. (That's why female villains have big noses.)

Bridge of nose has a sweeping curve

Upturned tip

Mouths

DRAWING FEMALE LIPS

Maybe you're wondering, "Where are the instructions for drawing men's lips?" There aren't any—because they're not necessary. We treat men's lips as just simple lines, more or less. If they have some fullness to them, we still keep them simple. But on female characters, we pump the lips up—really exaggerate them. Botox city, baby!

We generally give attractive female characters a bit of an overbite, where the top lip hangs over the bottom. We frequently show the cupid's bow, that indentation in the middle of the top lip, but it's not essential. A shine is added to indicate a pair of particularly appealing lips, often with lipstick on them. The shine will appear on the lower lip, off to the side.

Front View	Side View	3/4 View

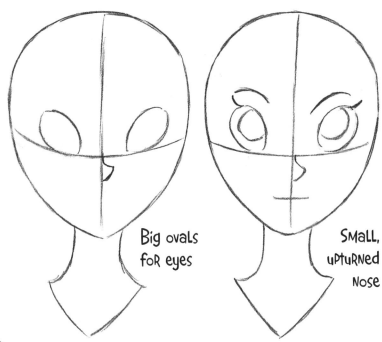

DRAWING MOUTH EXPRESSIONS

Here's a versatile character who we can use to practice humorous mouth expressions in the context of an entire face. As we showed on the previous page, her top lip is drawn to give her a slight overbite and very full lips.

Big ovals for eyes

Small, upturned nose

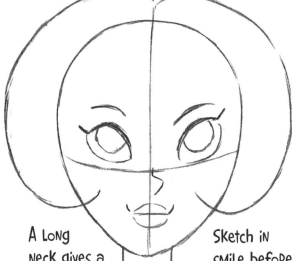

A long neck gives a funny look

Sketch in smile before adding thickness to lips

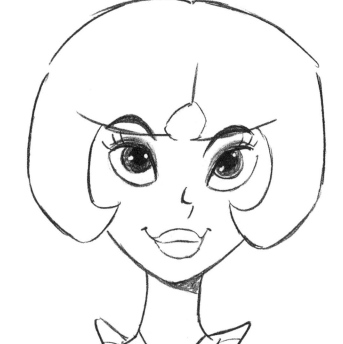

Fill out the lips, but leave the curl of the smile as a line

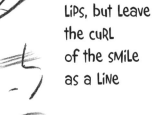

DRAW UPPER EYELID AND LASHES THICK AND DARK, ADD HIGHLIGHT TO PUPIL

MORE FEMALE MOUTH EXPESSIONS

A woman's full lips can also be given the subtle treatment, leaving more of the expressive work for the eyes. But the eyes don't do all the work. Together with the lips and the nose, they convey a character's attitude and emotions.

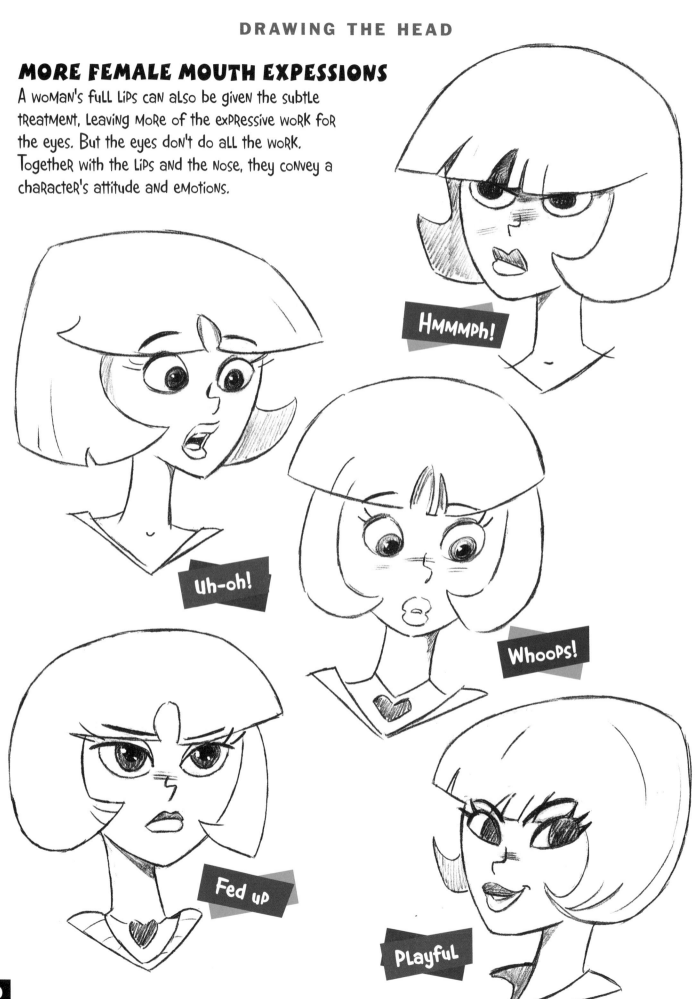

Hmmmph!

Uh-oh!

Whoops!

Fed up

Playful

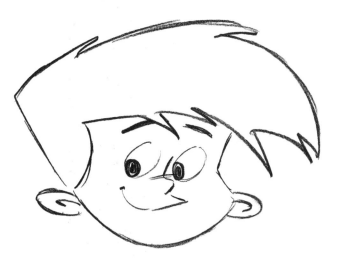

MOUTH NEUTRAL

 MOUTH PUSHED UP

EXTREME MOUTH MOVEMENT

Unlike the nose, the mouth doesn't have to remain fixed in one position. Make it rubbery!

The extreme mouth can be moved in four basic directions: up, down, left and right. Of course, you can combine these directions, so that a mouth can also move on a diagonal. But here are the basic positions:

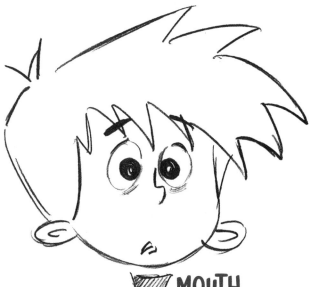

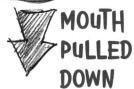 MOUTH PULLED DOWN

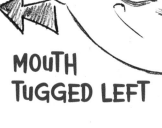

MOUTH TUGGED LEFT

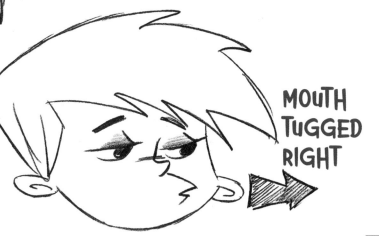

MOUTH TUGGED RIGHT

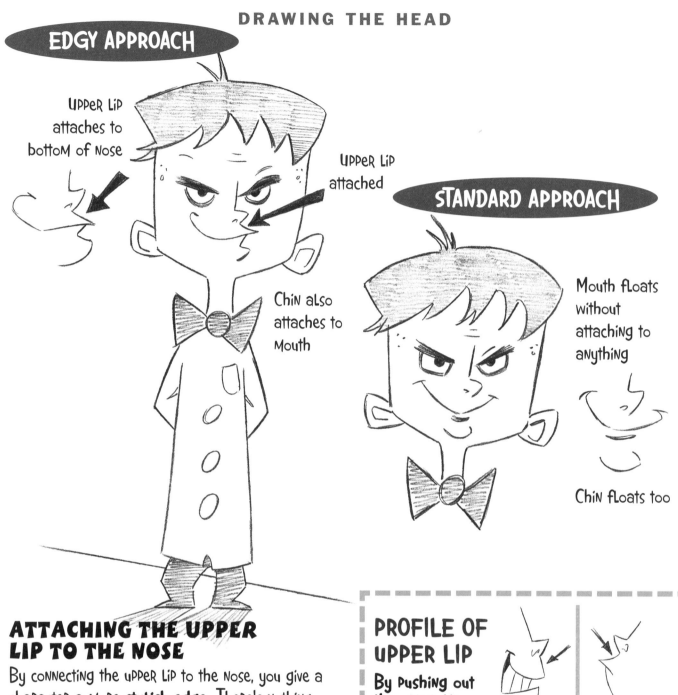

EDGY APPROACH

UPPER LiP attaches to bottom of Nose

UPPER LiP attached

Chin also attaches to Mouth

STANDARD APPROACH

Mouth floats without attaching to anything

Chin floats too

ATTACHING THE UPPER LIP TO THE NOSE

By connecting the upper lip to the nose, you give a character a more **stylish edge.** There's nothing wrong with the standard approach of keeping the nose and mouth separate, but there's something appealing about adding a little edge to your work. That said, the standard approach is still superior for cute characters. The edgy approach, however, is better for quirky, bizarre and slightly evil characters.

Using this stylish, edgy look, we attach the character's upper lip to the bottom of the nose. This can be done in any view: front, side or 3/4. This attached style of mouth is most often used for male characters.

PROFILE OF UPPER LIP

By pushing out the upper lip slightly you somehow make it funnier! This exaggerated approach to the upper lip, though only a small touch, instantly makes a character more humorous.

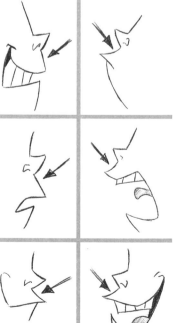

PULLING AND SQUASHING THE MOUTH

Now let's get really extreme with mouth-based facial expressions. Let's pull and push the mouth, really yank it around in all directions to create elastic expressions. The features within the face in this extreme mode should expand and contract, never staying in one place.

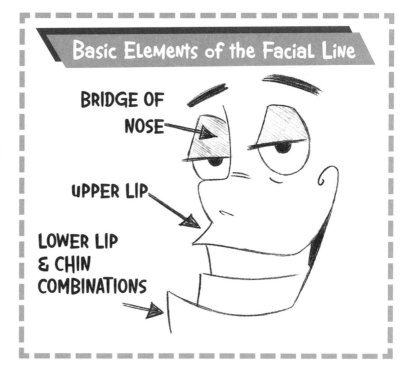

Basic Elements of the Facial Line

BRIDGE OF NOSE

UPPER LIP

LOWER LIP & CHIN COMBINATIONS

TILT

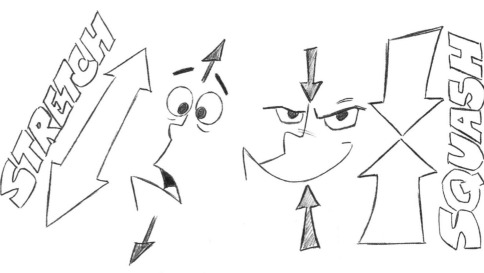

STRETCH

SQUASH

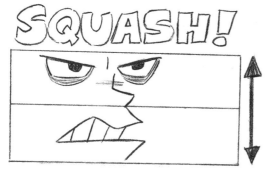

SQUASH!

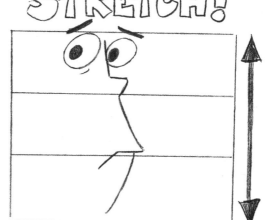

STRETCH!

UNDERCOVER ACTION HERO

Now, using a POPULAR cartoon character type, the UNDERCOVER Action Hero, we'll show some examples of goofy expressions using the edgy-style mouth. As you'll recall, this is the style where the upper lip attaches directly to the bottom of the nose. For our model, we'll use a typical suburban cartoon neighbor: the undercover action spy. The character's humor comes from the fact that, though he wants everyone to think he's a typical suburban dad, his gigantic chin, unbelievably robust neck and massive build make it apparent that he's not an everyday meek, scrawny commuting office-type. Here's how to construct him:

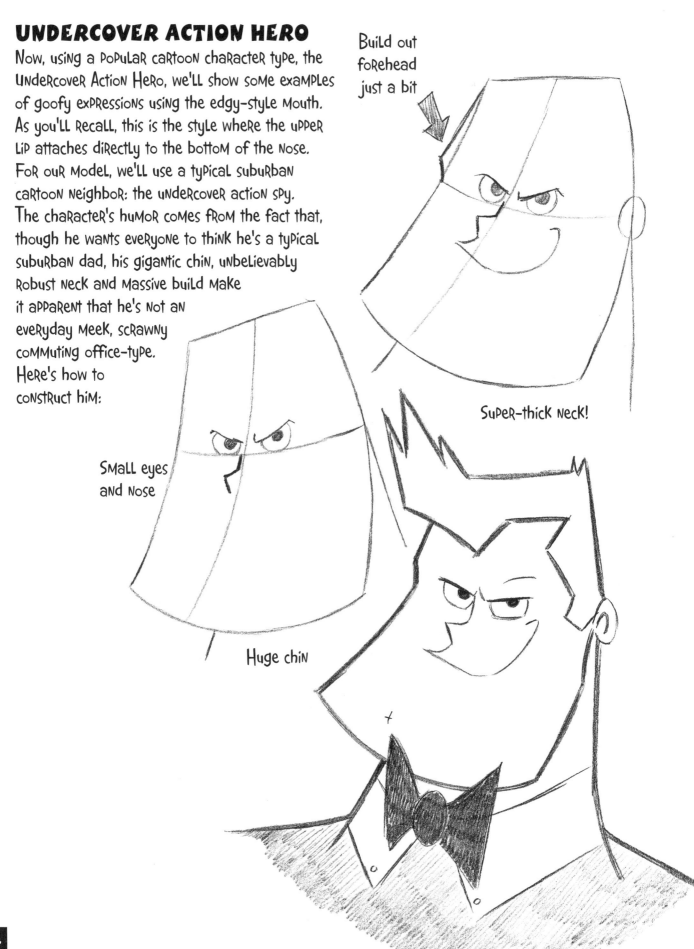

Build out forehead just a bit

Super-thick neck!

Small eyes and nose

Huge chin

EDGY MOUTH EXPRESSIONS

The edgy mouth style is great because it's so expressive and elastic. If you can think of an expression, this technique can convey it. Here's our Undercover Action Hero again, modeling a variety of expressions.

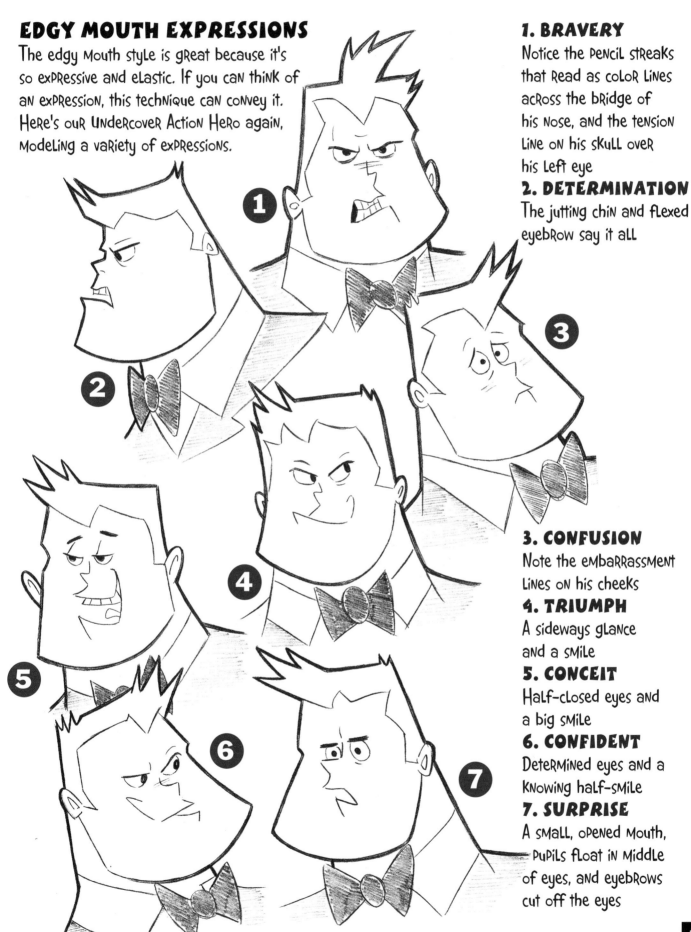

1. BRAVERY
Notice the pencil streaks that read as color lines across the bridge of his nose, and the tension line on his skull over his left eye

2. DETERMINATION
The jutting chin and flexed eyebrow say it all

3. CONFUSION
Note the embarrassment lines on his cheeks

4. TRIUMPH
A sideways glance and a smile

5. CONCEIT
Half-closed eyes and a big smile

6. CONFIDENT
Determined eyes and a knowing half-smile

7. SURPRISE
A small, opened mouth, pupils float in middle of eyes, and eyebrows cut off the eyes

35

HairStyles

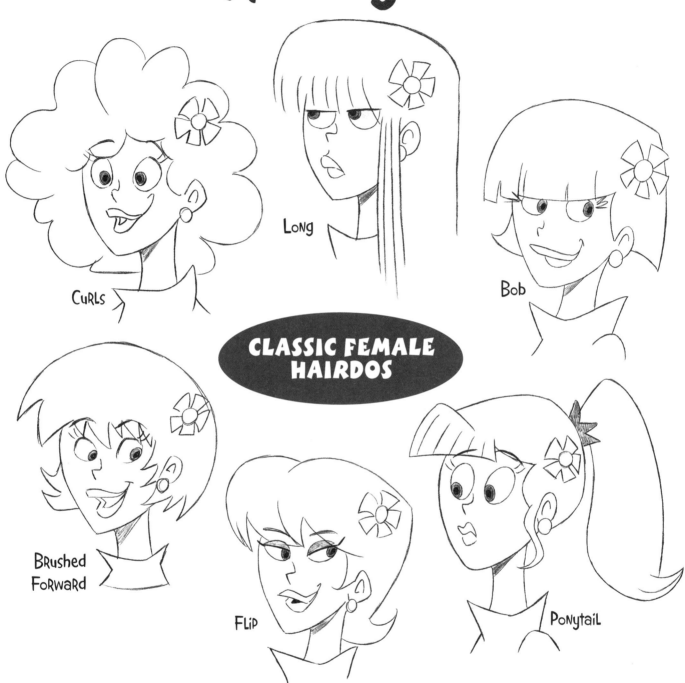

Curls

Long

Bob

CLASSIC FEMALE HAIRDOS

Brushed Forward

Flip

Ponytail

You can do a lot of characterization through the hairstyles of your female characters. Don't know much about hairstyling? Well, open any fashion magazine and you'll see everything from extremely attractive to over-the-top ridiculous cuts. In general, stay away from extreme styles that distract the audience from the character's other traits. Of course, if you have a character who is vain, a ridiculously overdone hairdo might express exactly what you want to say about her. Another example of a case where extreme hair is appropriate is the goth-type character, whose hair covers most of her face. Touches like that are pertinent to the specific character and help to illustrate personality.

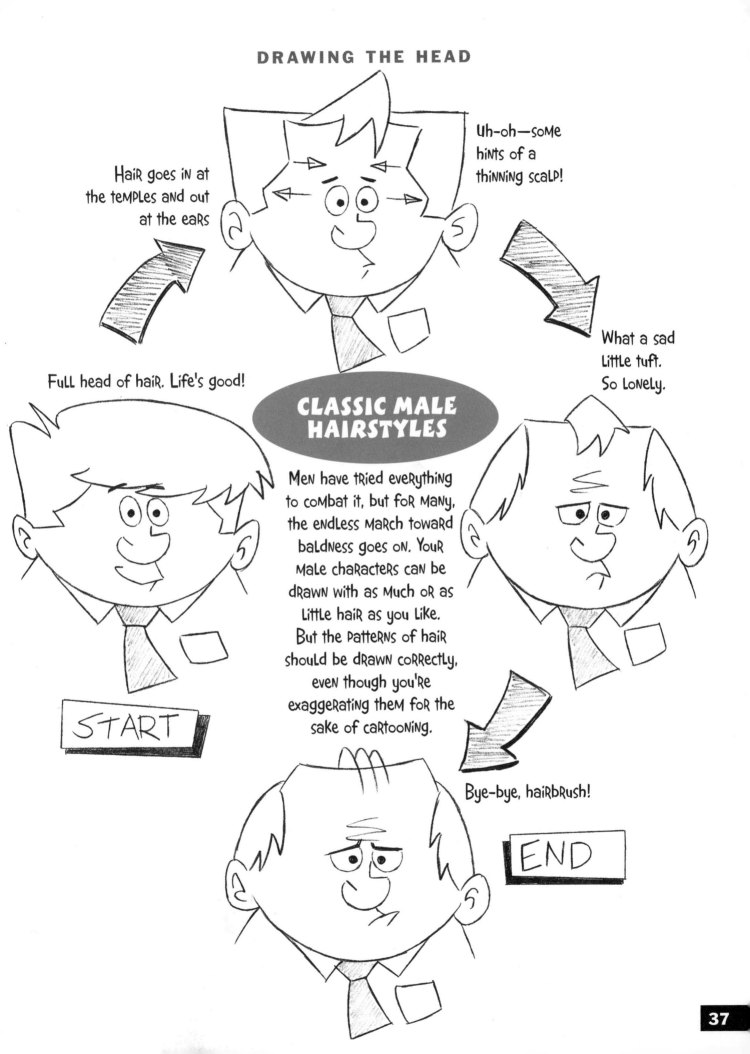

Hair goes in at the temples and out at the ears

Uh-oh—some hints of a thinning scalp!

What a sad little tuft. So lonely.

Full head of hair. Life's good!

CLASSIC MALE HAIRSTYLES

Men have tried everything to combat it, but for many, the endless march toward baldness goes on. Your male characters can be drawn with as much or as little hair as you like. But the patterns of hair should be drawn correctly, even though you're exaggerating them for the sake of cartooning.

START

Bye-bye, hairbrush!

END

37

Drawing Bodies

We now open the vault to the secrets of drawing stylish, edgy cartoon bodies. My approach consists of three points:

- ● Important hints
- ● Basic shapes
- ● Basic proportions

Remember: it's more important that they're funny than that they're perfectly correct.

IMPORTANT HINTS

● The average cartoon character is 4–6 heads (literally, the height of the character's head) tall. Younger and cuter characters can be as compact as 2 heads tall, while lanky models can be drawn 10–12 heads tall.

● Female characters have very high waistlines.

● The elbow naturally occurs at the level of the waist, or at the level of the lowest rib—you can feel it on yourself!

● The hands, when relaxed, fall at around mid-thigh level, or slightly above that.

● Draw an inwardly bent knee for a feminine look.

● Square shoulders actually give female characters an attractive appearance. The shoulders and hips should be roughly the same width.

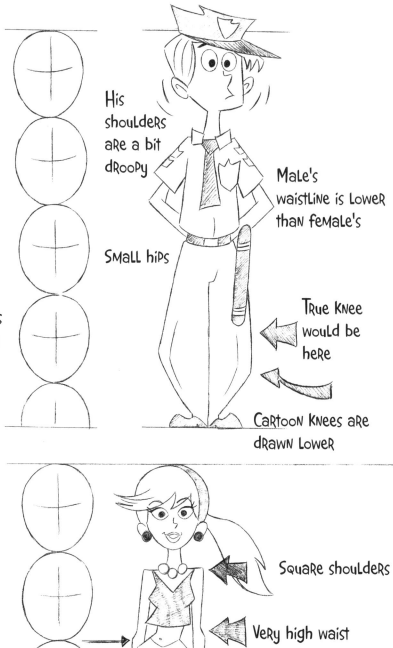

His shoulders are a bit droopy

Small hips

Male's waistline is lower than female's

True knee would be here

Cartoon knees are drawn lower

Square shoulders

Very high waist

Hands at Mid-thigh

Knee bent inward

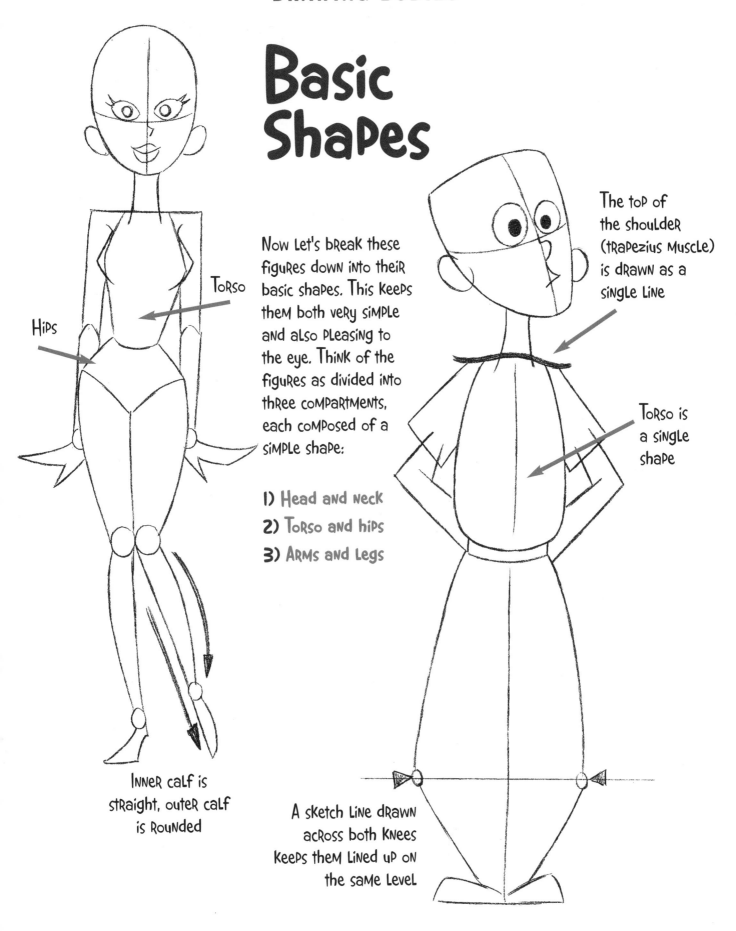

Basic Shapes

Torso

Hips

Now Let's break these figures down into their basic shapes. This keeps them both very simple and also pleasing to the eye. Think of the figures as divided into three compartments, each composed of a simple shape:

1) Head and neck
2) Torso and hips
3) Arms and Legs

The top of the shoulder (trapezius muscle) is drawn as a single line

Torso is a single shape

INNER calf is straight, outer calf is Rounded

A sketch line drawn across both knees keeps them lined up on the same level

39

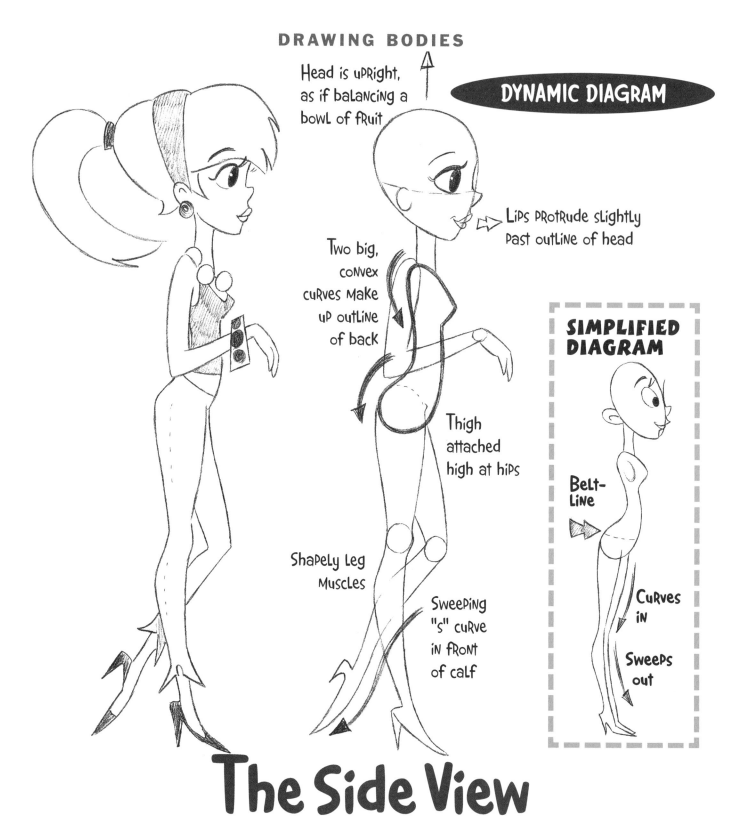

Head is upright, as if balancing a bowl of fruit

DYNAMIC DIAGRAM

Lips protrude slightly past outline of head

Two big, convex curves make up outline of back

SIMPLIFIED DIAGRAM

Thigh attached high at hips

Belt-Line

Shapely Leg Muscles

Sweeping "S" curve in front of calf

Curves in

Sweeps out

The Side View

The average cartoon guy looks kind of like a **doofus,** while the average cartoon gal is attractive. In both cases, though, the side view is trickier than it might appear, because it has a tendency to look stiff. But there's an easy way to overcome that: simply watch out for—and avoid—that **stiff-as-a-board look** in the character's back or front.

The only flatness you'll see in any of these two figures is the cop's back—but it's offset by the fact that he's got a totally rounded front. And while one of the gal's legs appears to be straight, it's really not. On her straightened leg, her upper thigh as well as her calf is built with subtle curves. Nothing about her is stiff at all.

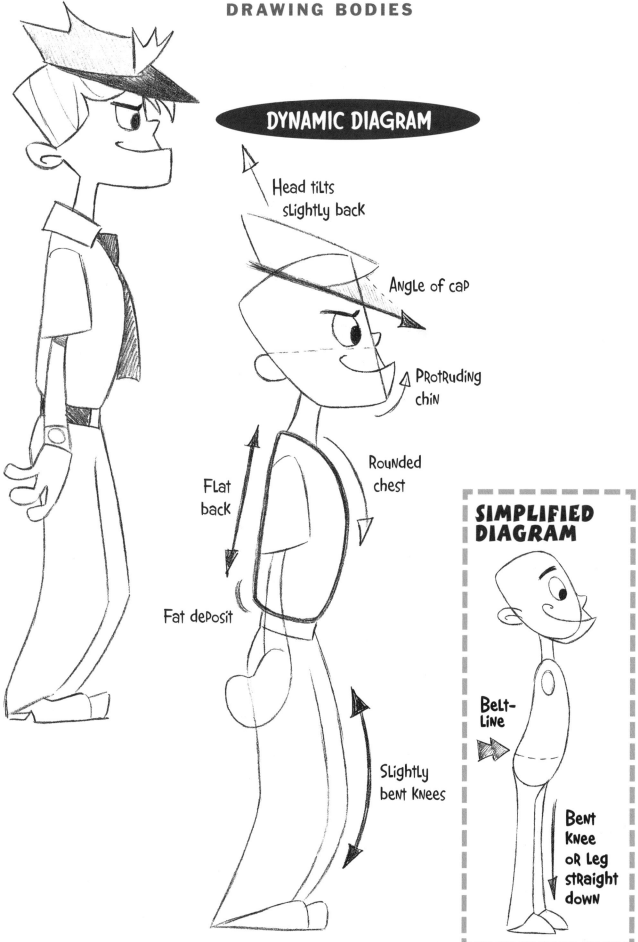

DYNAMIC DIAGRAM

Head tilts slightly back

Angle of cap

Protruding chin

Flat back

Rounded chest

Fat deposit

Slightly bent knees

SIMPLIFIED DIAGRAM

Belt-line

Bent knee or leg straight down

Basic Proportions

Talk about **character development!** You can take a single character and change the shape of her body to turn her into a completely different person. This should dispel the idea once and for all that a character is defined by her or his facial features. Character design is much more holistic than that—it includes proportion as well as costume (which we will cover later in the chapters on neighborhood types). **But don't jump ahead.** We still have a few tricks left up our sleeves.

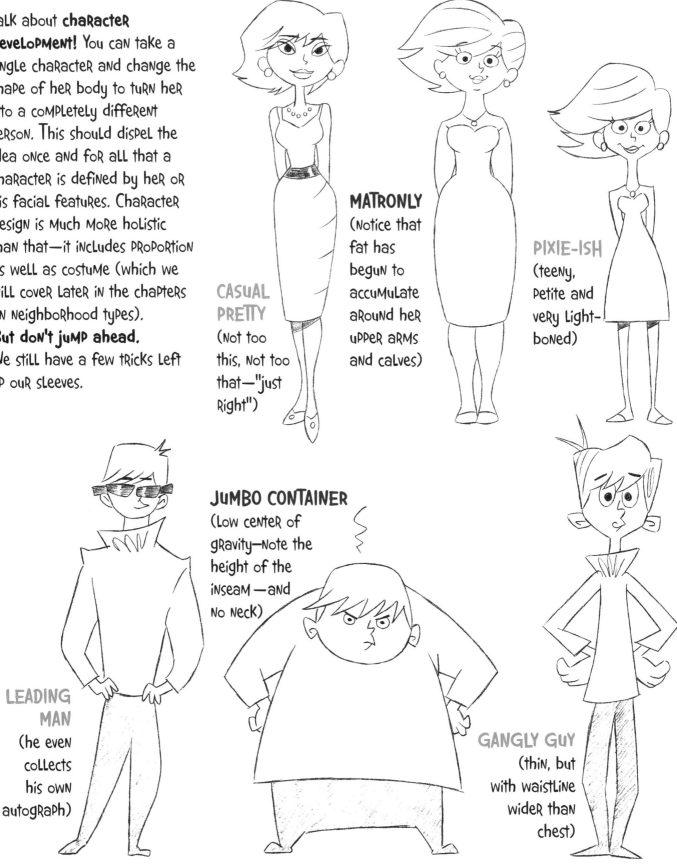

CASUAL PRETTY
(Not too this, not too that—"just right")

MATRONLY
(Notice that fat has begun to accumulate around her upper arms and calves)

PIXIE-ISH
(teeny, petite and very light-boned)

LEADING MAN
(he even collects his own autograph)

JUMBO CONTAINER
(Low center of gravity—note the height of the inseam—and no neck)

GANGLY GUY
(thin, but with waistline wider than chest)

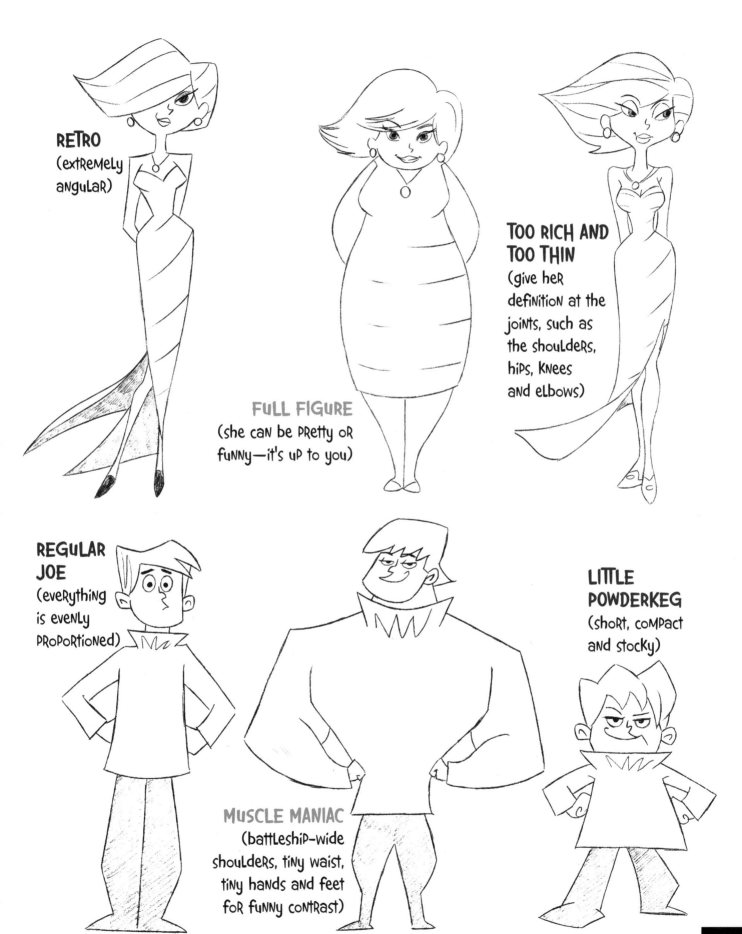

RETRO
(extremely angular)

TOO RICH AND TOO THIN
(give her definition at the joints, such as the shoulders, hips, knees and elbows)

FULL FIGURE
(she can be pretty or funny—it's up to you)

REGULAR JOE
(everything is evenly proportioned)

LITTLE POWDERKEG
(short, compact and stocky)

MUSCLE MANIAC
(battleship-wide shoulders, tiny waist, tiny hands and feet for funny contrast)

Hands

Just as you can express personality through a character's face and body, you can also do so through the hands. Generally, you want to match up body types with hand types: chubby, spindly, stubby, squarish and so on. Here are a few examples.

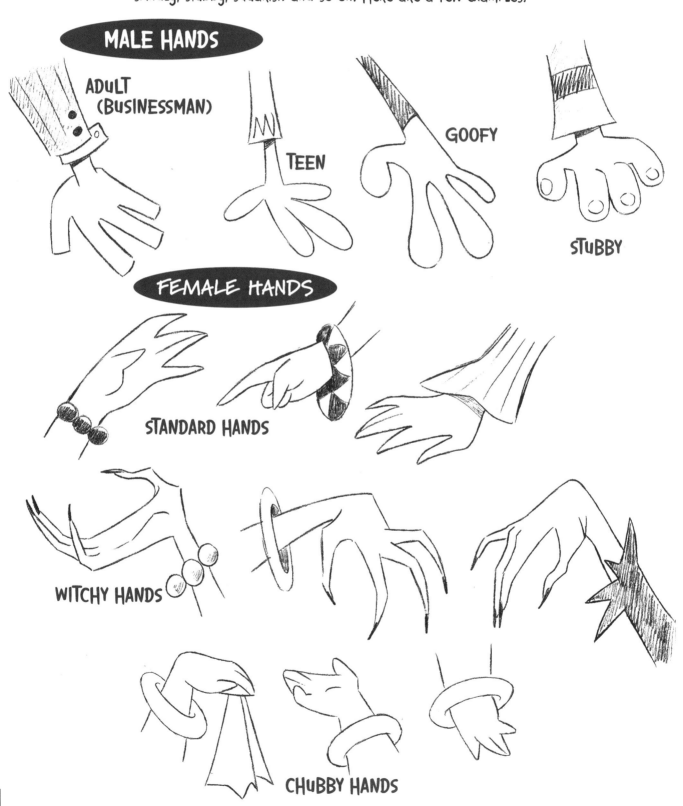

MALE HANDS

ADULT (BUSINESSMAN)

TEEN

GOOFY

STUBBY

FEMALE HANDS

STANDARD HANDS

WITCHY HANDS

CHUBBY HANDS

FINGERS AND THUMBS

Be sure you draw a distinct but small middle bone in the thumb.

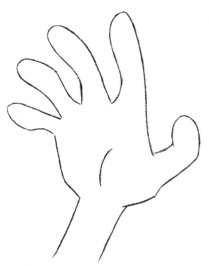

Fingers are amazingly flexible: they can **bend up** as the wrist **bends down**

FIVE FINGERS

(Five is fine and anatomically correct, of course, but when the fingers are big and cartoony, the hand can look a little crowded)

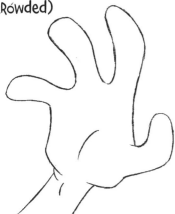

Same thing, seen from the **opposite side**

FOUR FINGERS

(A widely accepted cartooning convention)

Be sure to give the fingers a **NATURAL CURVE**

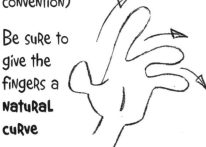

KNUCKLES

Create a **wave-like** effect in a front view of the fist. The thumb wraps underneath the fingers

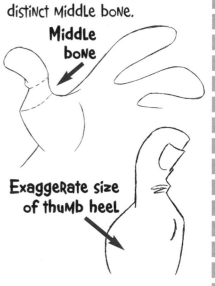
Omit **fingernails** for male hands

When the hand is wrapped into a fist, the thumb overlaps the fingers at a **diagonal**

When the fingers are held together, you can **level off the tips**

45

HAND GESTURES

Some gestures are enhanced by a few motion lines.

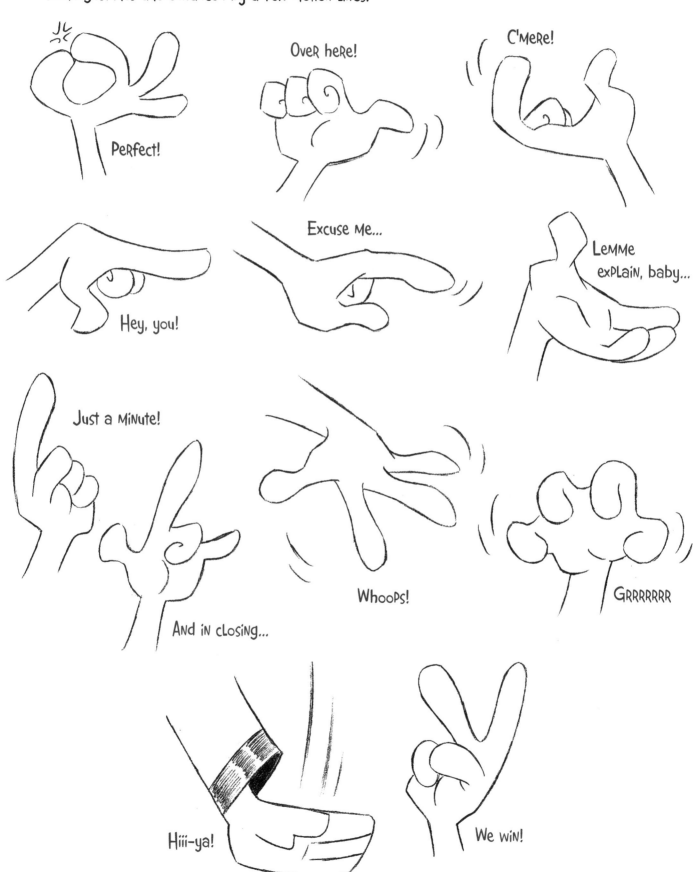

Footwear

Without well-drawn feet, you characters won't have a leg to stand on, so to speak. Feet—and footwear—say almost as much about your characters as their faces and hands do.

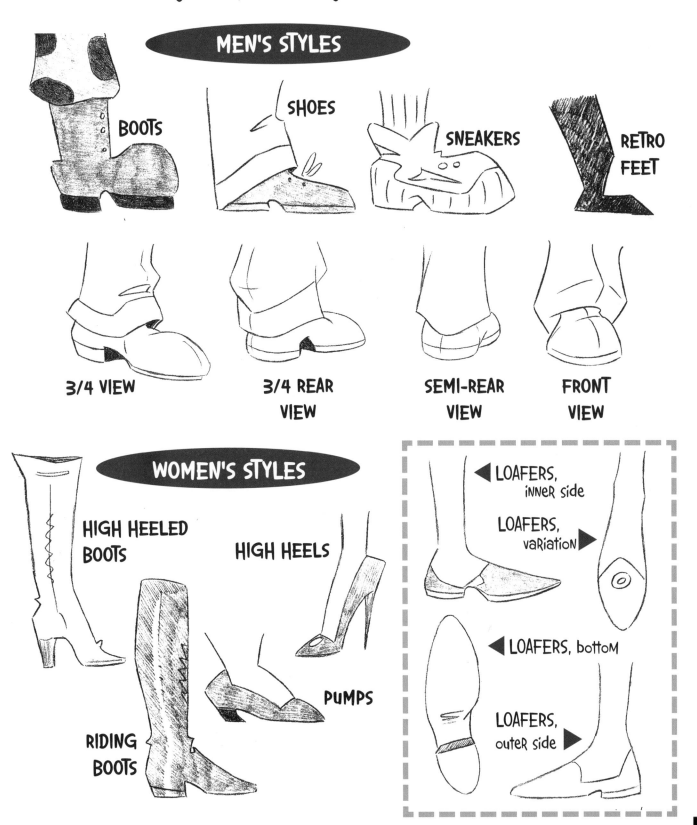

Action and Body Dynamics

Now let's take everything we've learned and put it together to draw convincing characters as they behave and move in life. (This is just an introduction to the topic. We'll get into it in more detail later, when I show you how to draw neighborhood types.)

BALANCE AND COUNTERBALANCE

As parts of a body move, other parts must move as well—so the body doesn't fall over! Here are some specifics on how that works.

Counterweight— **LEFT**

Counterweight— **RIGHT**

CENTER of balance

WEIGHT DISTRIBUTION

To maintain equilibrium, a body has to have equal amounts of weight distributed in front and in back. The body's center point is located at the pit of the throat or at the nose. With this portly fella, if you drew a line from the throat down to the ground, it would end at his heel, making him appear balanced. Both of his hands act as counterweights.

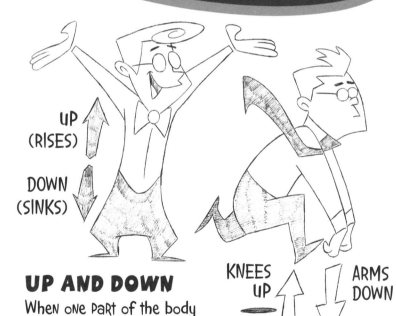

UP (RISES)

DOWN (SINKS)

KNEES UP

ARMS DOWN

UP AND DOWN

When one part of the body lifts up, another part of the body usually goes down. And in cartooning, we exaggerate these movements to add humor.

ACTION

REACTION

ACTION-REACTION

When a character moves part of his body in one direction, another part of his body usually (but not always) moves in the opposite direction.

DOUBLE-DIRECTION POSES

Closely related to the topic of balance is the double-direction pose. In this pose, you **add energy to your drawing** by turning a character's body away from the thing he's looking at. Take a look at the examples, and you'll immediately feel the extra energy the double-direction pose conveys. Just don't overuse this technique, or all of your characters will be looking at each other sideways, which isn't always appropriate to the story you want to tell.

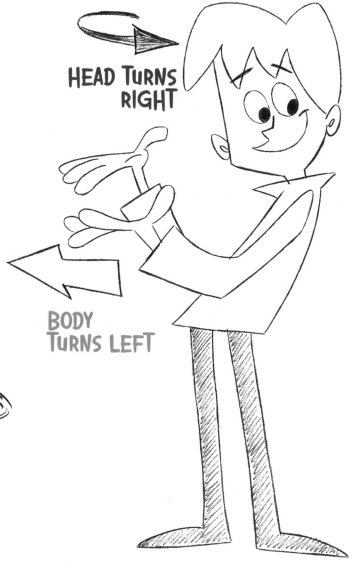

HEAD TURNS RIGHT

BODY TURNS LEFT

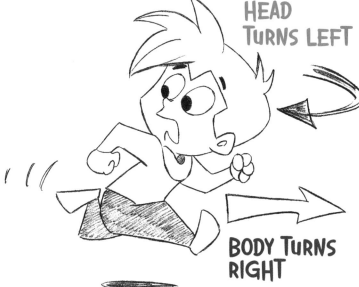

HEAD TURNS LEFT

BODY TURNS RIGHT

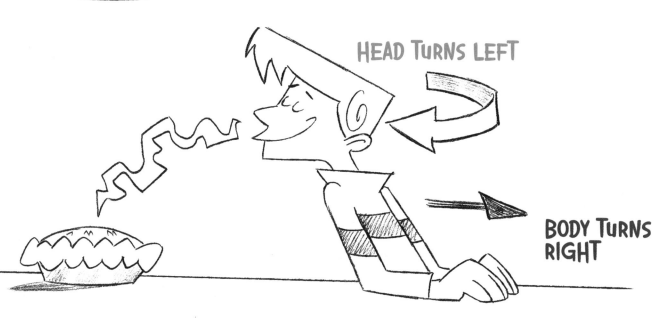

HEAD TURNS LEFT

BODY TURNS RIGHT

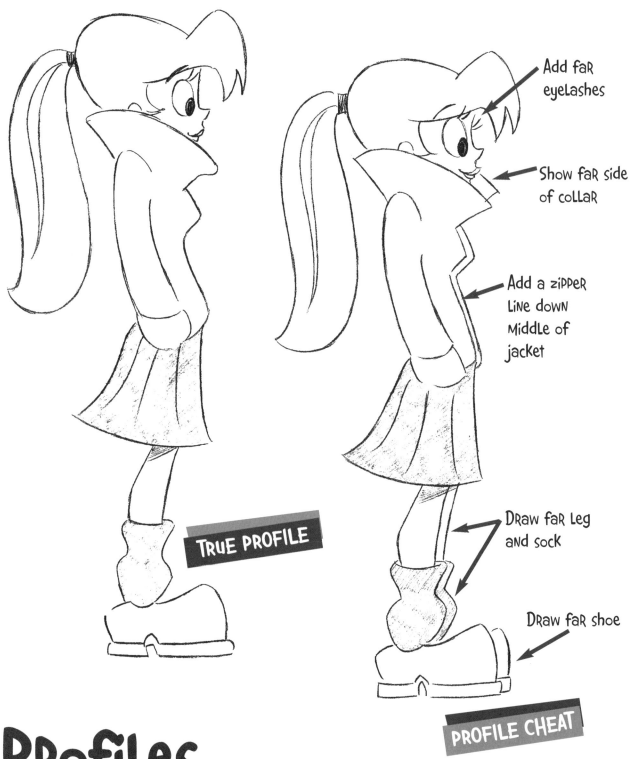

Add far eyelashes

Show far side of collar

Add a zipper line down middle of jacket

TRUE PROFILE

Draw far leg and sock

Draw far shoe

PROFILE CHEAT

Profiles

Profile seems like a pretty **simple concept.** A profile is a side view, plain and simple. But it's **not quite that simple.** If you draw a photographically accurate profile, your character will appear flat. It may look like you forgot to draw in the far limbs, even though, technically,

your drawing is correct.

To compensate for this, we **cheat a little** by turning the body ever so slightly into a 3/4 view. Note all of the cheats—modifications—in the second version of the girl. These make the side view look more lifelike than the first, flat version.

Coiling and Compression

When you put characters in motion, their bodies bend, or flex. And when something is flexed, it changes shape. As cartoonists, we simply can't resist the temptation to exaggerate anything that changes shape (especially when it affects a character's rear end).

There are two main ways to indicate flexing and flattening: coiling and compression.

COILING

Often affects the muscles of the upper arms and legs as they bend. Let's have a look.

COMPRESSION

Often affects the hindquarters of animals and people when they sit. The rear end widens out in a funny way—at least, it's up to us cartoonists to make it look funny!

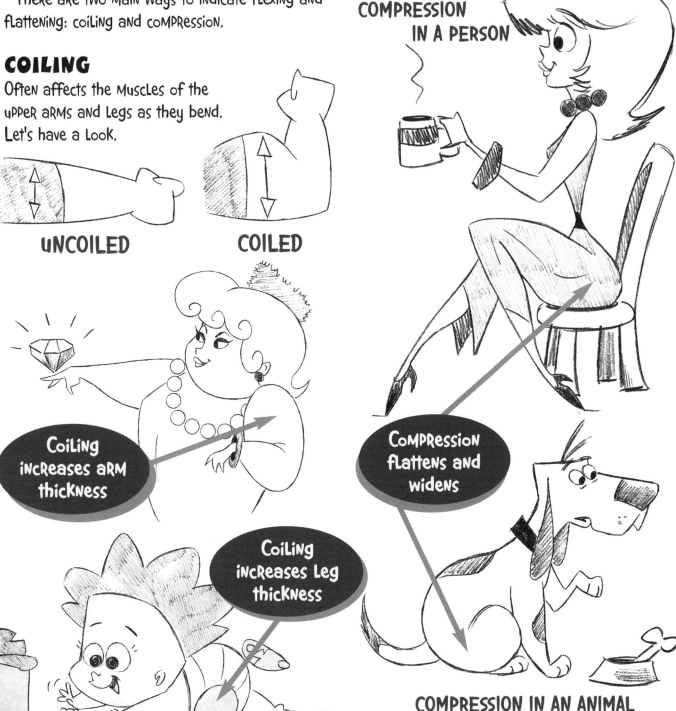

UNCOILED

COILED

COMPRESSION IN A PERSON

Coiling increases arm thickness

Coiling increases leg thickness

Compression flattens and widens

COMPRESSION IN AN ANIMAL

Stretching and Thinning

When a character stretches any part of his or her body, that part thins out. And if the character's entire body is involved in the stretching motion, the entire body gets thinner, even if the character is fat. This effect caricatures the action and makes it funnier.

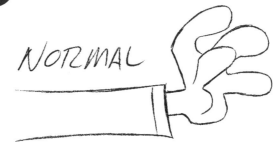

NORMAL

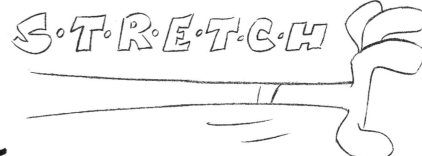

S·T·R·E·T·C·H

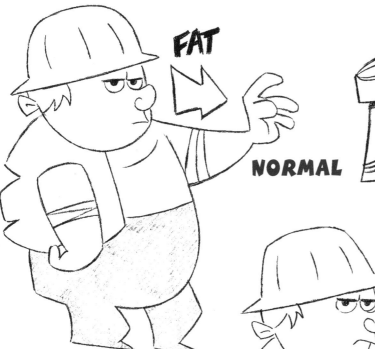

FAT

NORMAL

THINS OUT

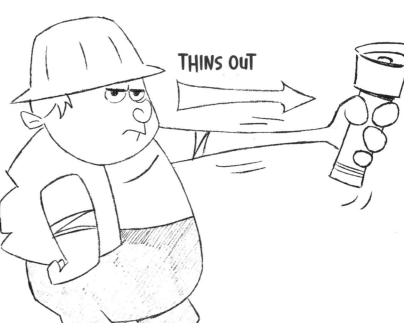

Points of Emphasis

The most effective character designs are those in which the artist emphasizes one body area over the others to create a specific personality and humorous appearance. This kind of emphasis will affect the way your character moves. For example, a brainy character with a huge head and tiny body will be off-balance if he tries any activity more athletic than reading. A woman with a large caboose will take tiny tiptoe steps. A big, brawny guy will swagger, shifting his barrellike chest from side to side as he walks.

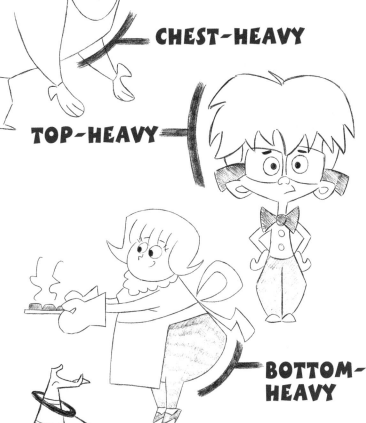

CHEST-HEAVY

TOP-HEAVY

BOTTOM-HEAVY

THIN

EXTRA-THICK

THICK

THIN

THICK

THICK

THIN

THIN

FAT TO THIN

When you draw big characters, whether they are female or male, it's funny to give them a dainty touch by super-slenderizing them at the wrists and ankles. With this technique, you create humor by contrasting two things that shouldn't really work together, but somehow do.

Posture and Personality

You can convey an infinite array of attitudes and expressions through posture. To simplify things, we can boil down the relationship between posture and personality to one rule of thumb: Characters with **Positive** (happy, confident, victorious) attitudes and feelings have their chests puffed out. Characters with **negative** (sad, angry, scared) attitudes and feelings have their chests sunken in.

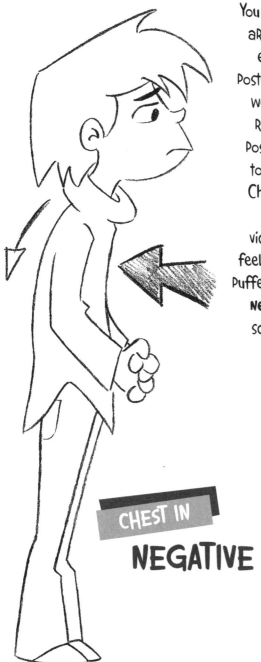

CHEST IN

NEGATIVE

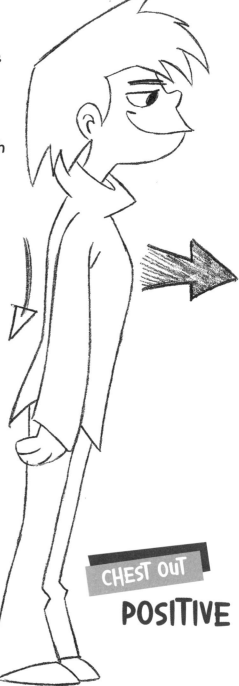

CHEST OUT

POSITIVE

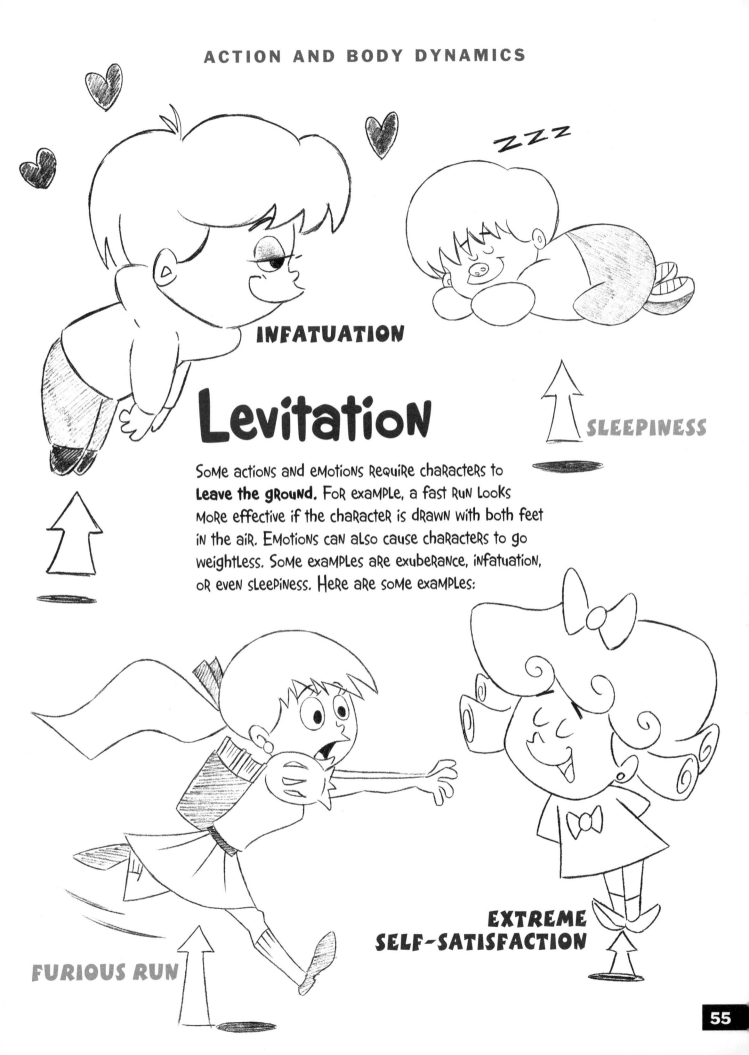

INFATUATION

ZZZ

Levitation

SLEEPINESS

SOME actions and emotions require characters to **leave the ground.** For example, a fast run looks more effective if the character is drawn with both feet in the air. Emotions can also cause characters to go weightless. Some examples are exuberance, infatuation, or even sleepiness. Here are some examples:

FURIOUS RUN

EXTREME
SELF-SATISFACTION

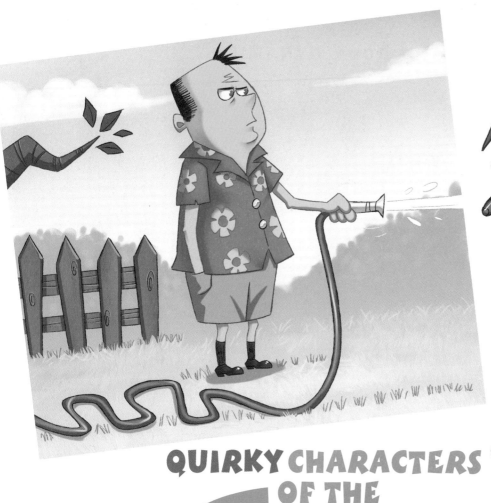

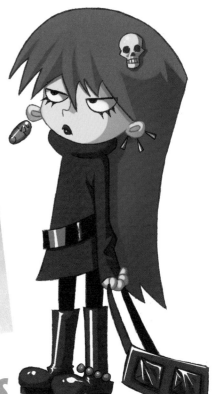

QUIRKY CHARACTERS OF THE SUBURBS

Welcome to that hotbed of satire and mirth—your local suburb! It's just a commuter train ride away!

We're starting off in the **burbs** because this is far and away the most popular spawning ground for today's cartoon characters. The majority of cartoon characters, whether they're in animated TV shows or movies, comic strips or comic books, come right out of suburbia. And why not? **Underneath every suburban home's** aluminum-sided veneer lies a house full of weird characters just waiting— begging!—to be lampooned.

Tilt head

Short, beefy arms

Super-wide chest

Draw a shadow to indicate the ground

Line of shoulders becomes Line of arm

Small hands

Tiny Legs and feet

Pit of neck affixes to the center Line

Inner Legs drawn as a single, curved Line

Coach Dad

This guy turns into a **full-fledged Lunatic** the moment a call goes against his kid's team. This type of character is exaggerated from head to toe because of his high-voltage emotional state. Giganticize his torso and super-shrink his legs. Draw tiny hands and feet to emphasize his girth. Give him a block head, a crew cut and a thick neck, making him look more like a drill sergeant than a dad. The greater the space between the cap and the head, the more motion of the entire body is suggested.

Rigid body Reflects character's temperament

ALL-AMERICAN SOCCER MOM

Bright eyes with pupils floating inside

Simplified torso shape

Very long neck

Simplified hip shape

You can run, you can hide, but you can't get away from the soccer mom. This character is **PERKY** to the point of being **irritating**. The key to getting her down pat is her wide-eyed look, achieved by drawing the pupils small, so they swim in the middle of the whites. Stiff eyelashes seem to float off the eyeballs, adding to the overall effect. And don't forget to give her that round head!

Collar up

Hairstyle is a "MOM-do"

Bottom of hem is curved, not straight

HINT Both feet on the ground is ok, but one foot up gives her that PERKY look.

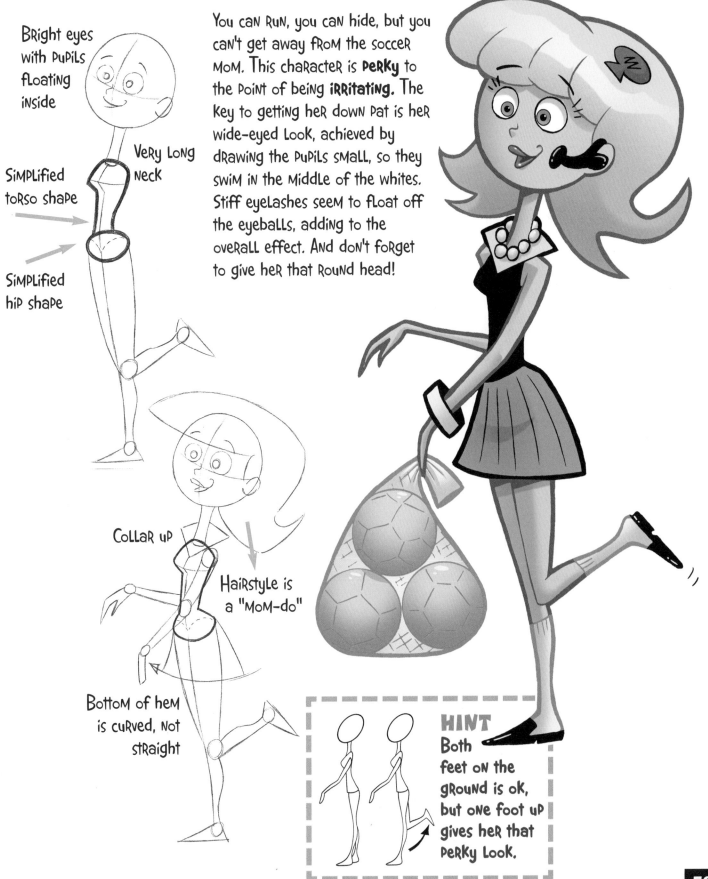

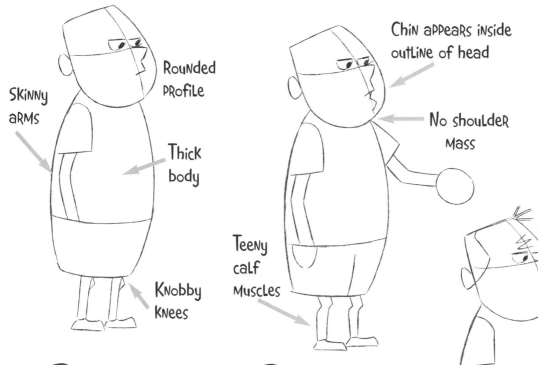

Skinny arms

Rounded profile

Thick body

Knobby knees

Chin appears inside outline of head

No shoulder mass

Teeny calf muscles

Furrowed brow

Tiny elbow joints

GRUMPY Guy

Midlife blues can strike anywhere, even (or especially) in the suburbs. Case in point: this character type—the angry, unhappy guy. Along with his sense of humor, his fashion sense has deserted him, too.

DETAIL
Open shirt collar

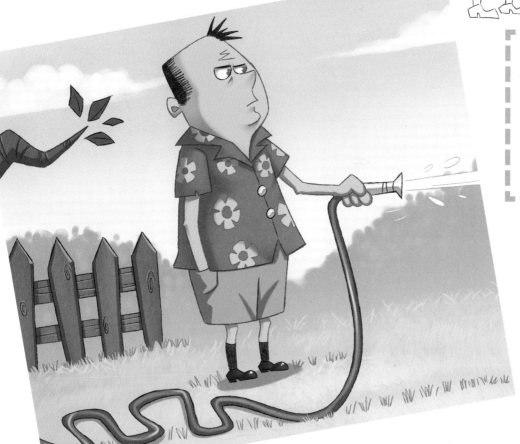

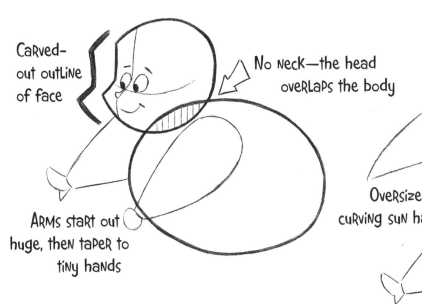

Carved-out outline of face

No neck—the head overlaps the body

Because of her fluffy hair, hat rests above the skull

Arms start out huge, then taper to tiny hands

Oversized, curving sun hat

The Turbo-Gardener

This overweight, **somewhat manic** suburban neighbor lives and dies by the flower petal. Lots of curls in the hair, tiny eyes (contrast well with the plump face) and a few floating eyelashes add up to a hyper look. Notice that her mouth has a small section of full lips, built on what is largely a linear smile. Finally, dainty little fingers look funny on this corpulent character.

Legs tuck underneath

Guy from the Witness Protection Program

Don't go to this guy's door to borrow a cup of sugar. He's very private about his personal affairs. Yep, the burbs are filled with all sorts of great characters for us cartoonists—you just have to dig a little to find them! But don't dig too deep, or you might find **a buried body**—yours!

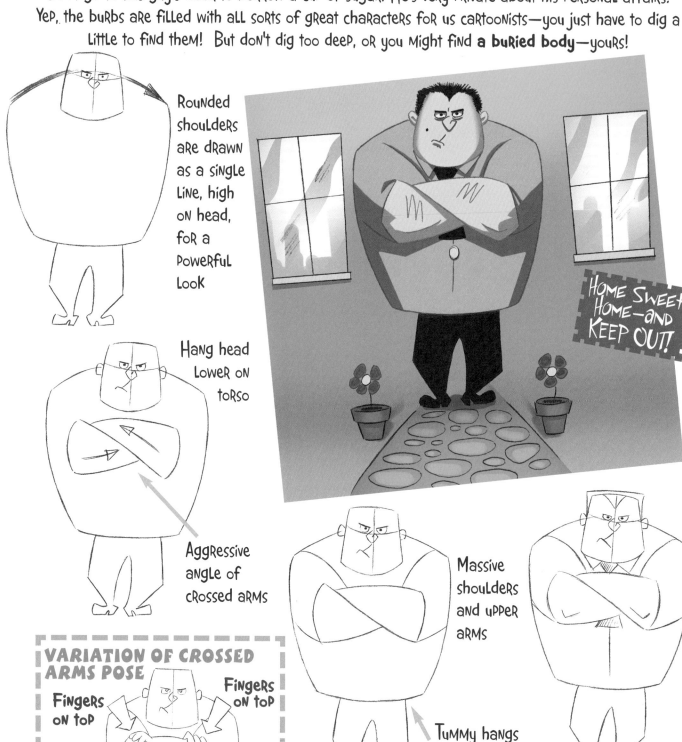

Rounded shoulders are drawn as a single line, high on head, for a powerful look

Hang head lower on torso

Aggressive angle of crossed arms

HOME SWEET HOME—AND KEEP OUT!

Massive shoulders and upper arms

Tummy hangs over pants

VARIATION OF CROSSED ARMS POSE

Fingers on top

Fingers on top

Fingers on top

Diner Waitress

The jaded diner waitress does not find you adorable or even mildly amusing. It's **"What-do-ya-want-hon?"** And don't take more than five seconds to make up your mind, or she'll decide for you.

She's in a permanent state of standing with her hips flexed outward, impatiently waiting. Draw a skinny waist, wide hips and long legs. Her hips make a good resting spot for her hand, almost like a tabletop.

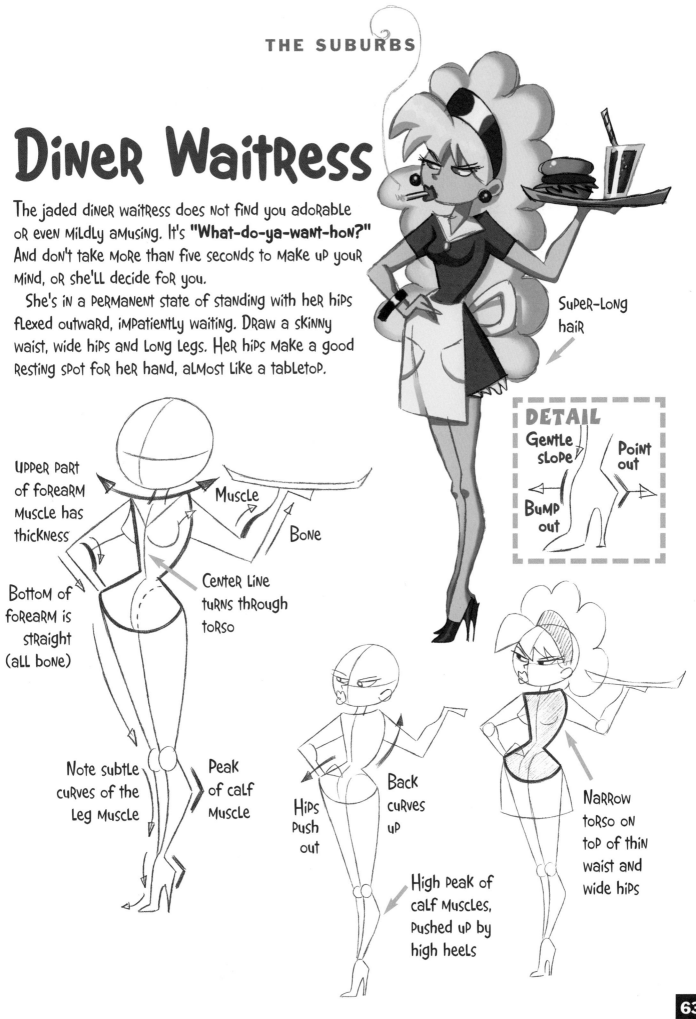

Super-long hair

DETAIL
Gentle slope
Point out
Bump out

Upper part of forearm muscle has thickness

Muscle

Bone

Bottom of forearm is straight (all bone)

Center line turns through torso

Note subtle curves of the leg muscle

Peak of calf muscle

Hips push out

Back curves up

High peak of calf muscles, pushed up by high heels

Narrow torso on top of thin waist and wide hips

Mysterious Neighbor

Who is this guy? What does he do? He always smiles, but he's a little creepy. Why does he always lug around those human-body-size plastic garbage bags? And hasn't his wife been on an extremely long "business trip"? The trick with drawing this guy is to draw him so normal that he's weird.

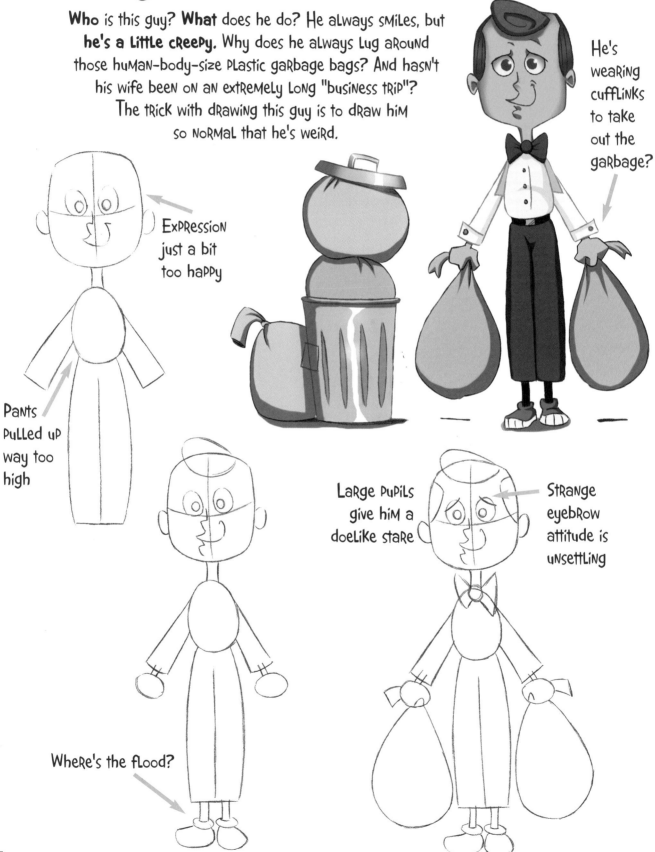

He's wearing cufflinks to take out the garbage?

Expression just a bit too happy

Pants pulled up way too high

Where's the flood?

Large pupils give him a doelike stare

Strange eyebrow attitude is unsettling

School Psychologist

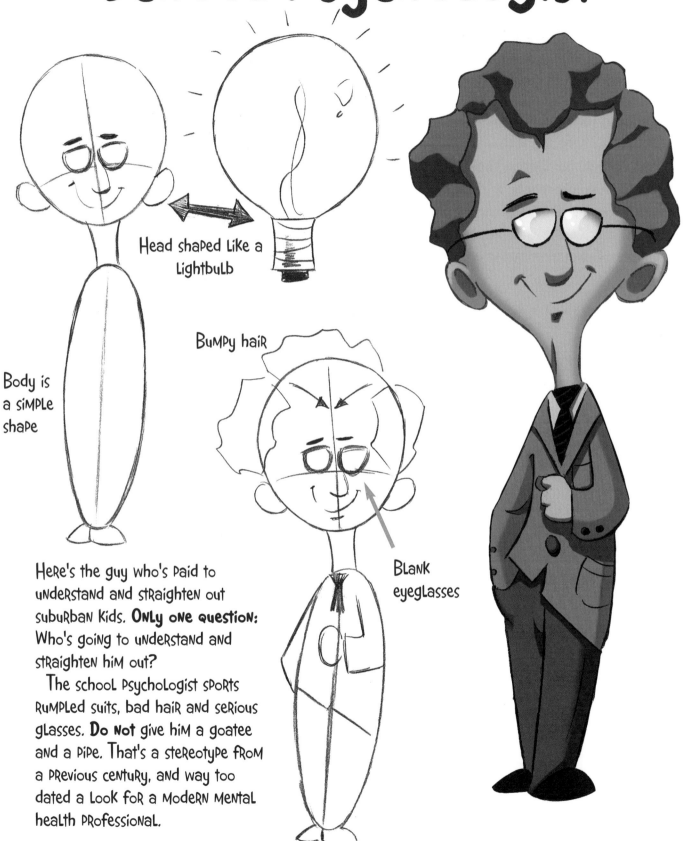

Head shaped like a lightbulb

Body is a simple shape

Bumpy hair

Blank eyeglasses

Here's the guy who's paid to understand and straighten out suburban kids. **Only one question:** Who's going to understand and straighten him out?

The school psychologist sports rumpled suits, bad hair and serious glasses. **Do not** give him a goatee and a pipe. That's a stereotype from a previous century, and way too dated a look for a modern mental health professional.

The Neighborhood Dog Target

Show up with a mailbag, and even a **toy poodle** will become **a ferocious defender** of hearth and home.

Mail carriers can be any character type, old or young, any body shape. I prefer young characters, because they can be clueless while retaining a degree of sweetness and naïveté.

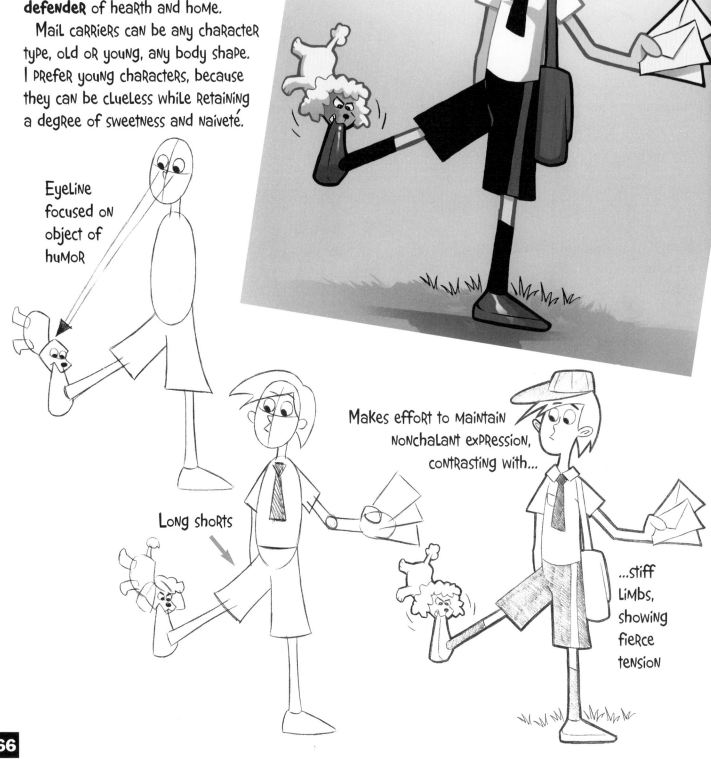

Eyeline focused on object of humor

Long shorts

Makes effort to maintain nonchalant expression, contrasting with...

...stiff limbs, showing fierce tension

Pizza Delivery Guy

A typical teen character, Pizza Guy is elongated, lanky and awkwardly built. He's got a small chin and a narrow chest, which makes him look **extra-goofy** (as does the 90-degree angle of his large clown feet). Twist his cap backward so his scruffy hair pokes out from underneath.

Remember how we added humor to a fat person (the gardener) by giving her dainty little hands? With a skinny character, we do the opposite. We give him big, fat fingers.

Low-set ears

Long neck

Big, fat fingers are goofy

So are fat feet

COUNTERBALANCE

To hold the pizza up, his other arm points down and out

Angle cap's visor down for a funny look

Small chin

No shoulders

Legs remain slim

Bell-bottom pants emphasize big feet

67

The World's Most Dangerous Yellow Belt

This **super-serious** kid and his totally aloof mom make a funny pair. The thing that makes this duo work as a comedy team is that they are in two totally separate realities: the kid is spinning out of control in his kung-fu fantasy world while his mom is just checking off another errand on her list (pick up the kid, drop off the dry cleaning...) Make the kid **chunky and bite-sized** to convey the idea that his kicks and punches are **completely harmless.**

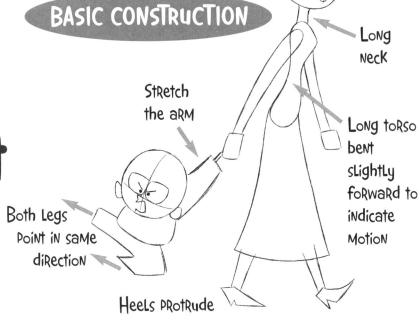

BASIC CONSTRUCTION

Long neck

Long torso bent slightly forward to indicate motion

Stretch the arm

Both legs point in same direction

Heels protrude

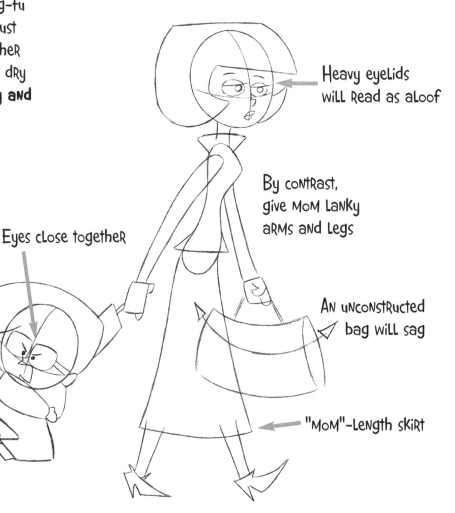

Heavy eyelids will read as aloof

By contrast, give mom lanky arms and legs

An unconstructed bag will sag

"Mom"-length skirt

Eyes close together

Shoulder covers chin

Classic foot position for karate flying kick

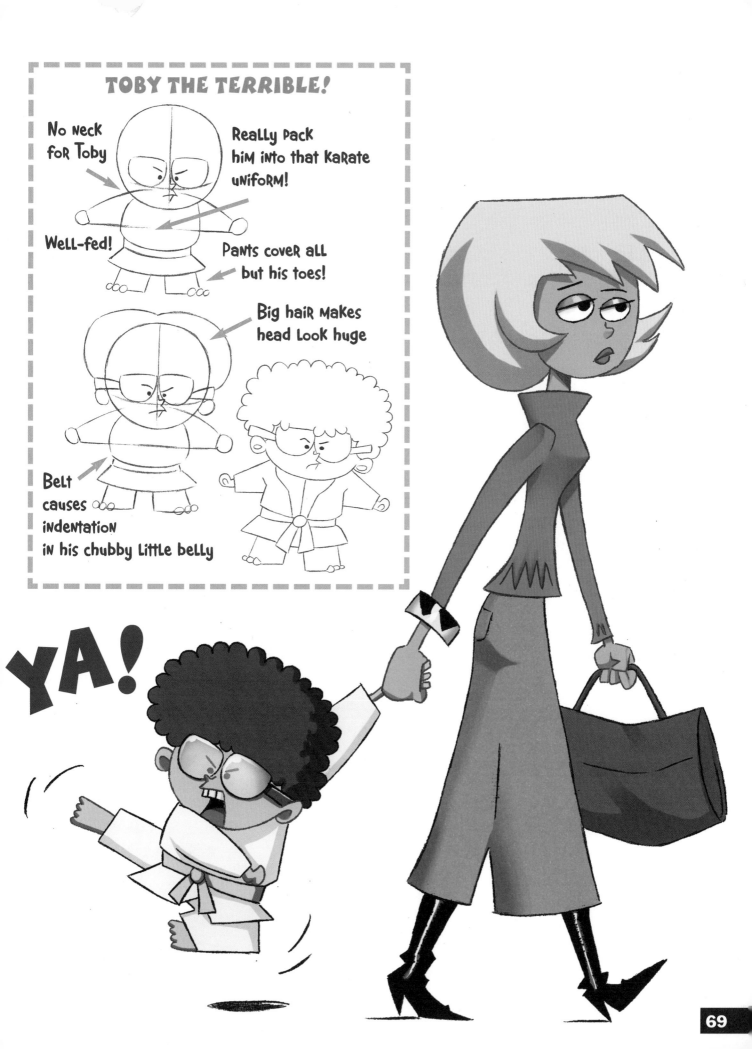

TOBY THE TERRIBLE!

No neck for Toby

Really pack him into that karate uniform!

Well-fed!

Pants cover all but his toes!

Big hair makes head look huge

Belt causes indentation in his chubby little belly

YA!

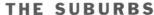

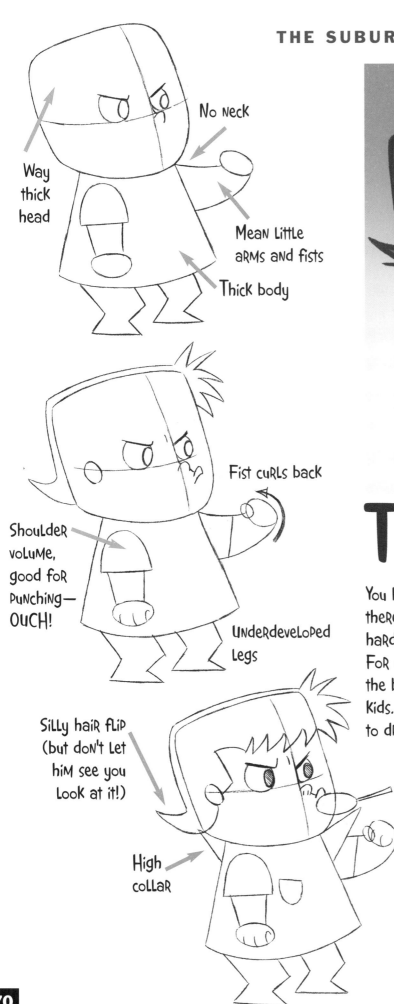

Way thick head

No neck

Mean little arms and fists

Thick body

Fist curls back

Shoulder volume, good for punching— OUCH!

Underdeveloped legs

Silly hair flip (but don't let him see you look at it!)

High collar

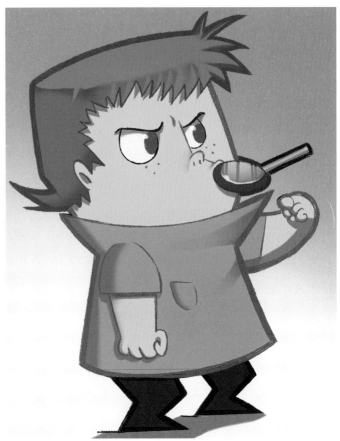

The Bully

You know how your parents always told you that there's a good side in everyone if you just look hard enough? Well, not for a cartoonist there isn't! For our purposes, **some kids are all bad**—like the bully. He's thicker and stronger than the other kids. In fact, **he's downright scary**. Let's see how to draw the character everyone loves to hate.

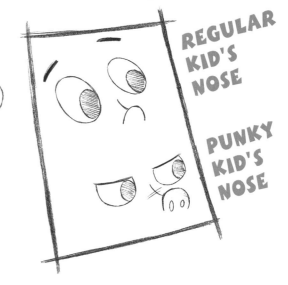

REGULAR KID'S NOSE

PUNKY KID'S NOSE

HypeRactive Student

This fidgety little guy **can't sit still,** which makes him a nightmare for his parents and teachers but a dream for the cartoonist. As he leaps out of his seat and bounces off the walls, he accelerates the pace of scenes to **manic speed.**

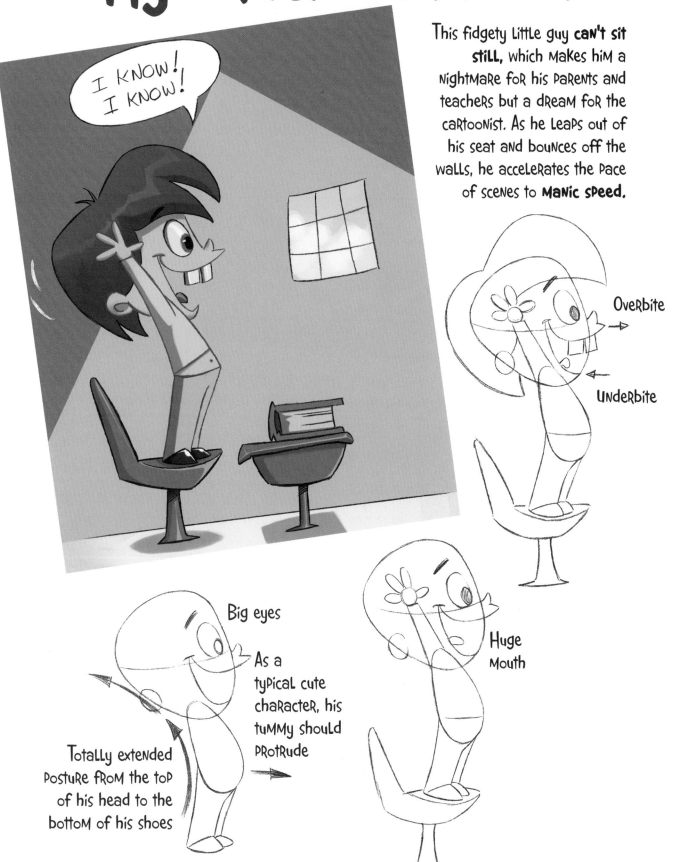

I KNOW! I KNOW!

Overbite

Underbite

Big eyes

As a typical cute character, his tummy should protrude

Huge Mouth

Totally extended posture from the top of his head to the bottom of his shoes

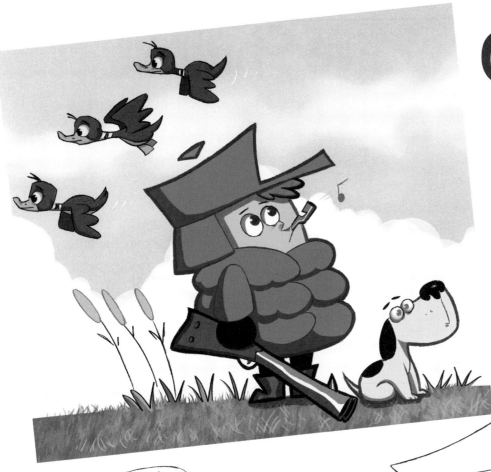

Clueless Hunter

This kid has been encouraged to **stop playing video games** and do something useful, like shoot some birds. But don't worry: no animals are harmed on animated TV shows, since the animals are smarter than the hunters.

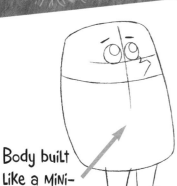

Body built like a mini-refrigerator

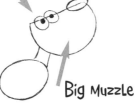

Two eyes on same side of head for a funny look

Big Muzzle

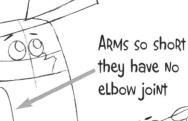

Gigantic cap

Arms so short they have no elbow joint

Tiny legs

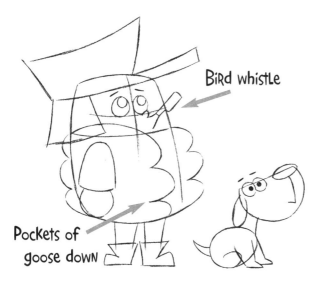

Bird whistle

Pockets of goose down

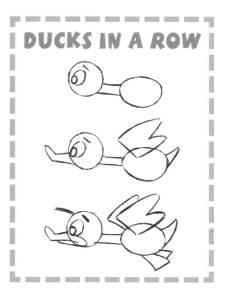

DUCKS IN A ROW

Kid Genius

Young geniuses like this **mad scientist** require a giant head perched atop a tiny body. The face is always saddled with fuddy-duddy eyeglasses through which we see little eyes. The nose and mouth are small and subtle. He also gets **big hair,** using Einstein as a role model.

Bottom of Robot's body is drawn at level of genius's nose

Small body

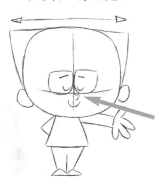

Wide top of head

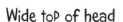

Eyeglass lenses touch each other

Stems of glasses don't quite touch ears

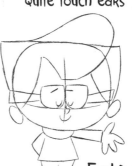

Eyebrows appear inside of lenses

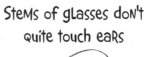

CoMPuter NeRd

The oNLy exeRcise this kid eveR gets is tapping oN the keyboard. This type of PeRsoN has Lost aLL contact with the outside woRLd—he hasN't Left his RooM iN weeks. That doesN't MeaN he has No fRieNds. He's got toNs of theM, **but oNLy oNLiNe.**

Tall head, to stoRe Lots of iNfoRMatioN

Eyes Rest oN bottoMs of glasses fRaMes, buRNiNg with siNgle-MiNded focus!

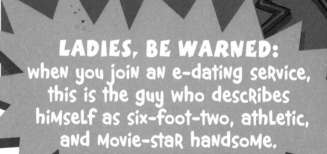

LADIES, BE WARNED:
wheN you joiN aN e-dating seRvice, this is the guy who descRibes hiMself as six-foot-two, athLetic, and Movie-staR handsoMe.

Lift Mouth uP to give appeaRaNce of a fat chiN

Shoulders hunched

ONLy the fiNgeRs Move. The uppeR aRMs aRe uNdefiNed

The Spy Next Door

Ever feel like you're **being watched?** You are, by your neighbor, the spy. You've been mistaken for the head of an international spy ring and your house is under surveillance.

Expect to see this **little agent** hiding in the bushes.

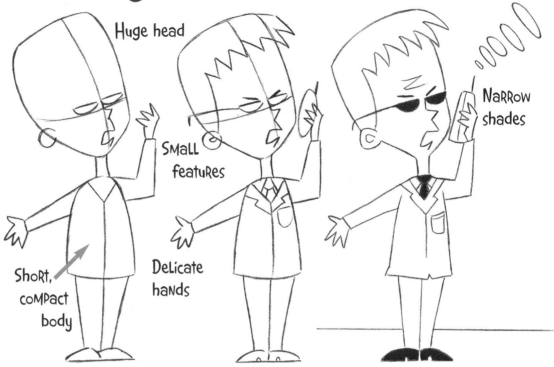

Huge head

Small features

Delicate hands

Short, compact body

Narrow shades

DETAIL
Drawing the suit collar and lapel

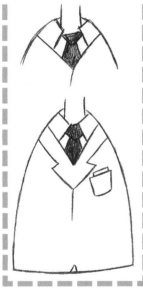

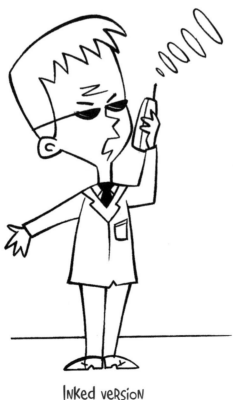

Inked version

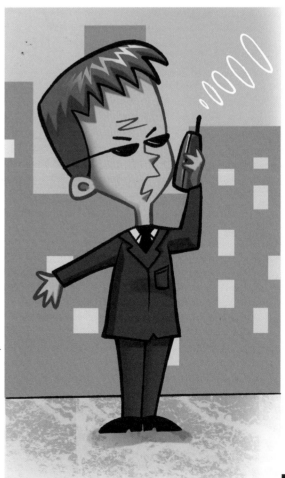

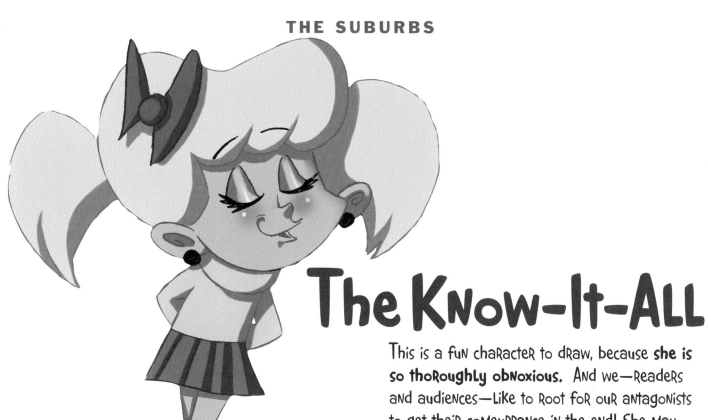

The KNOW-It-ALL

This is a fun character to draw, because **she is so thoroughly obnoxious.** And we—readers and audiences—like to root for our antagonists to get their comeuppance in the end! She may not look that hostile at first glance, but just give her a minute. The closed-eyes expression is a classic look that reads as self-assured to the point of arrogance. But the bottoms of the eyes (the heavy eyelashes) must curve upward. If they curve down, she'll look like she's quietly laughing, instead of condescending.

A lot of her attitude is conveyed through her body language. The know-it-all also has some general design traits: she usually has a large head, which means she's on the brainy side. To emphasize this, her body is small. She's neatly groomed, and, somehow, **she makes even that seem annoying.**

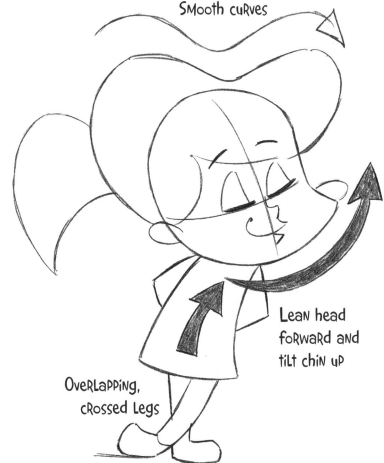

Smooth curves

Lean head forward and tilt chin up

Overlapping, crossed legs

DETAIL

Shoe tips come off ground

Feet rest on their sides

PhoNy PaL

We've all had **fRieNds** like this. He's your best buddy when he wants something, but he's **Ready to play you foR a chump** when it suits his needs. He's a fast-talking **coN aRtist iN tRaiNiNg.** This character type typically has a large head on top of a thin body—never athletic, he pRefeRs to get by on his wits. He's got a **big mouth** that's **always flapping,** and, usually, floppy hair as well.

Big head

Big Mouth!

Ear sticks out

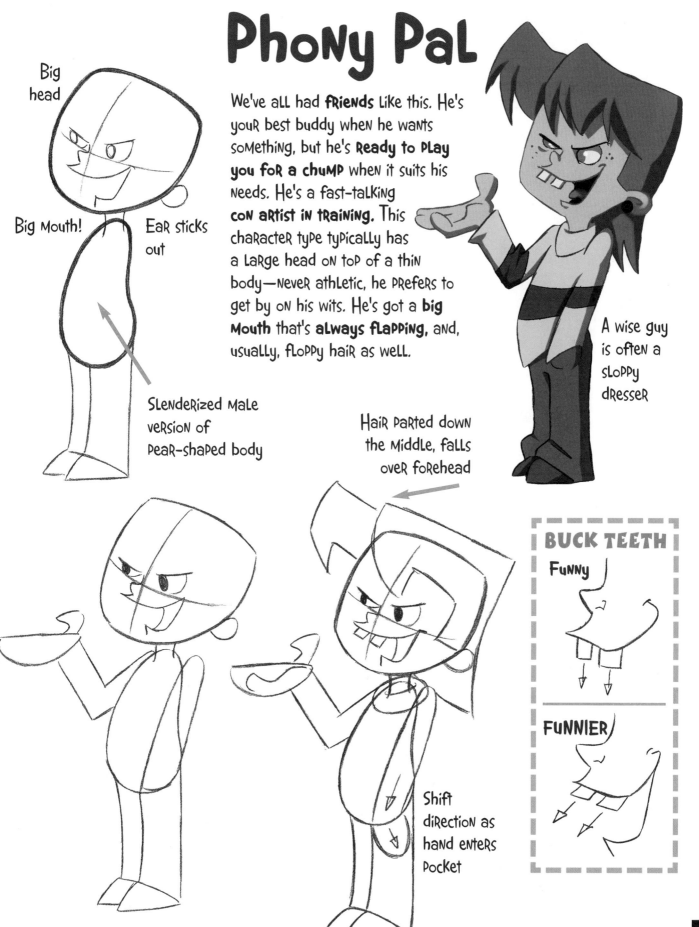

A wise guy is often a sloppy dresser

SLENDERIZED MALE VERSION OF PEAR-SHAPED BODY

HAIR PARTED DOWN the MIDDLE, falls oveR foRehead

Shift direction as hand enters Pocket

BUCK TEETH

Funny

FUNNIER

Goth Girl

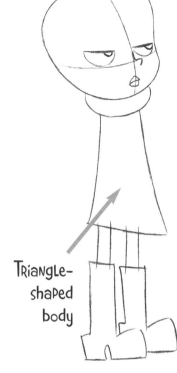

Triangle-shaped body

Some kids want to end world poverty, some want to cure cancer—and some want to pierce things that will upset their parents. The goth girl fits into this last category. She has two emotions: **gloomy and gloomier.** Goths have long, flat hair and wear loose, dark clothing. Their whole appearance says, **"Stay away, I'm ticked off and dangerous."**

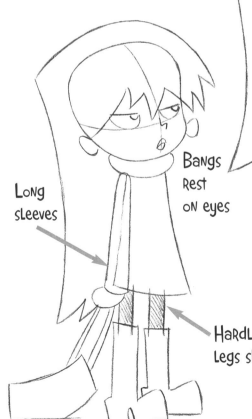

Long sleeves

Bangs Rest on eyes

Hardly any legs showing

Wide-set eyes for a creepy hostile look

HAIRDOS FOR MOPPETS

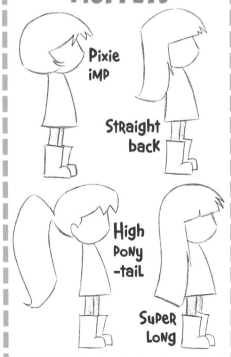

Pixie imp

Straight back

High Pony -tail

Super Long

Suburban Pet: The Beagle

To me, the beagle is the **quintessential suburban canine.** A case could certainly be made for the Labrador Retriever as well; however, for cartooning purposes, they don't have as interesting a construction as the beagle.

The beagle's long, floppy ears, swayback, domelike head and distinctive markings make it enjoyable to draw. And the short muzzle makes it **a real cutie.**

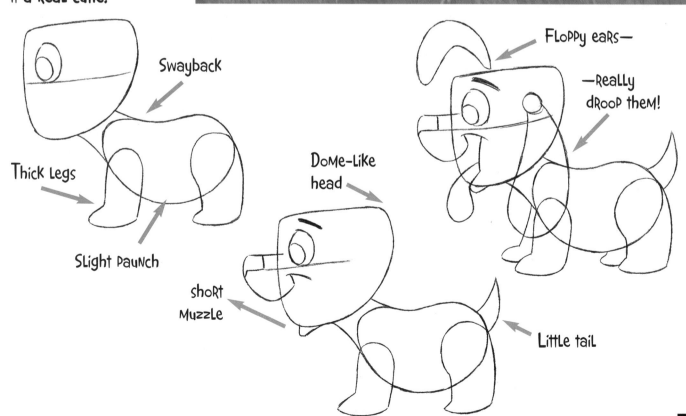

Swayback

Thick Legs

Slight Paunch

Dome-Like head

Short Muzzle

Floppy ears—

—Really droop them!

Little tail

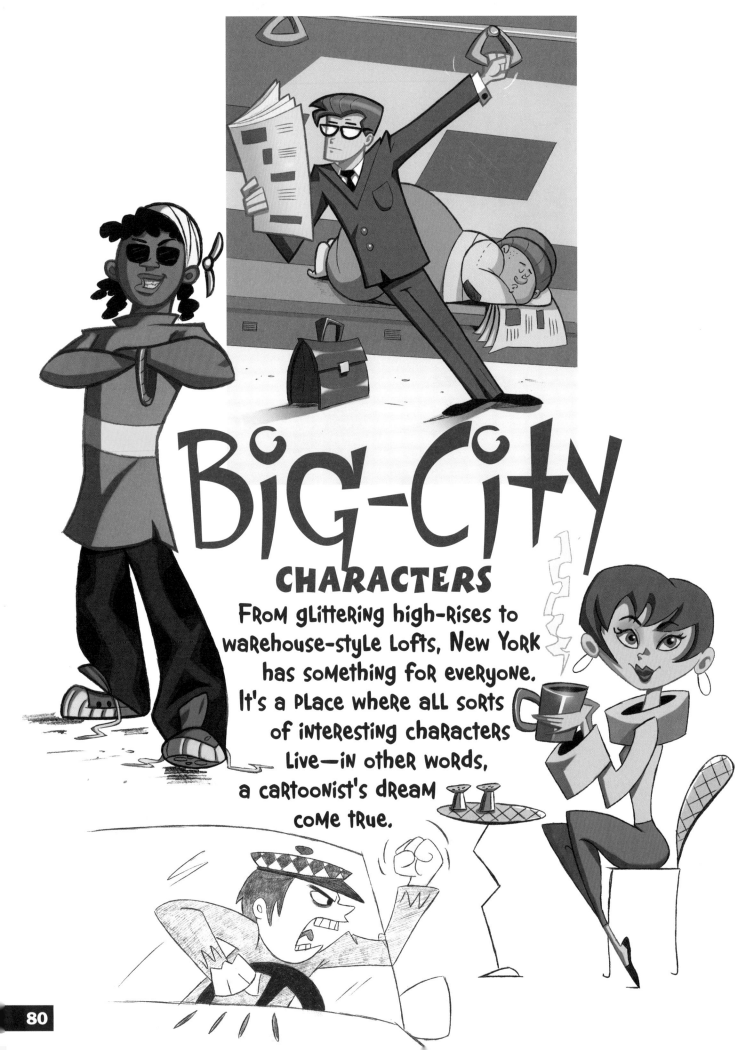

Big-City

CHARACTERS

From glittering high-rises to warehouse-style lofts, New York has something for everyone. It's a place where all sorts of interesting characters live—in other words, a cartoonist's dream come true.

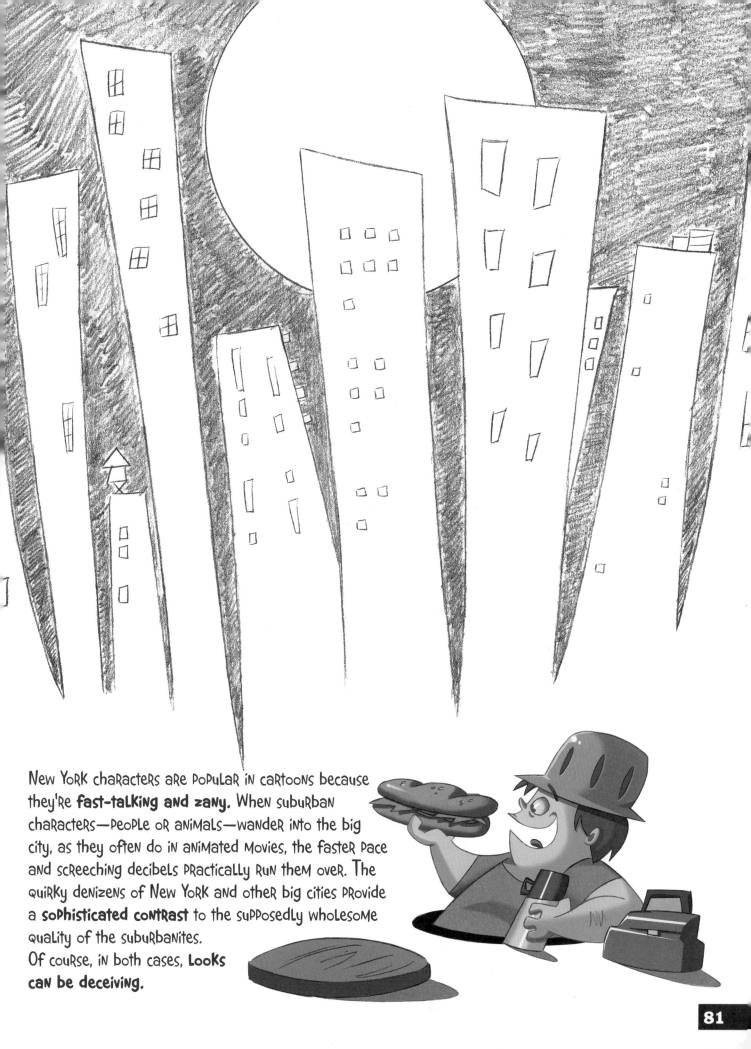

New York characters are popular in cartoons because they're **fast-talking and zany.** When suburban characters—people or animals—wander into the big city, as they often do in animated movies, the faster pace and screeching decibels practically run them over. The quirky denizens of New York and other big cities provide a **sophisticated contrast** to the supposedly wholesome quality of the suburbanites.
Of course, in both cases, **looks can be deceiving.**

DooRMan

He sees all, he knows all, **but he says nothing.** No, I'm not describing a CIA agent, but a doorman for a ritzy Park Avenue apartment building. This tight-lipped confidant of the elite knows all the secret goings-on of the building.

Conserving motion and form is the key to drawing this character. His missile-shaped silhouette is elegantly simple.

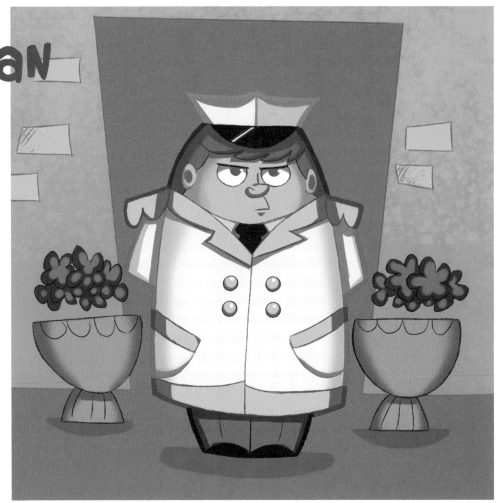

Begin with a very strong overall body shape

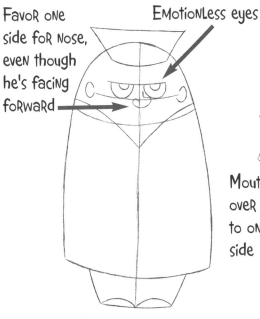

Favor one side for nose, even though he's facing forward

Emotionless eyes

Keep legs together (no space between them) to make him look immobile

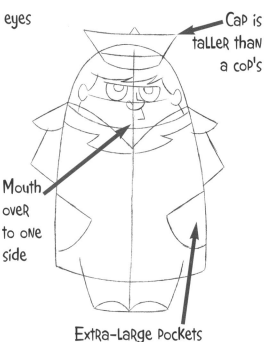

Cap is taller than a cop's

Mouth over to one side

Extra-large pockets

Hot Dog Vendor

FOR RICH AND POOR, young and old, this is every New Yorker's **favorite pit stop for lunch.** The fast-talking, twitchy (note the tongs) sidewalk vendor will call out his wares to you as you walk by. Anything you want to chat about, he's got an opinion—**just don't ask him** what's in those dogs!

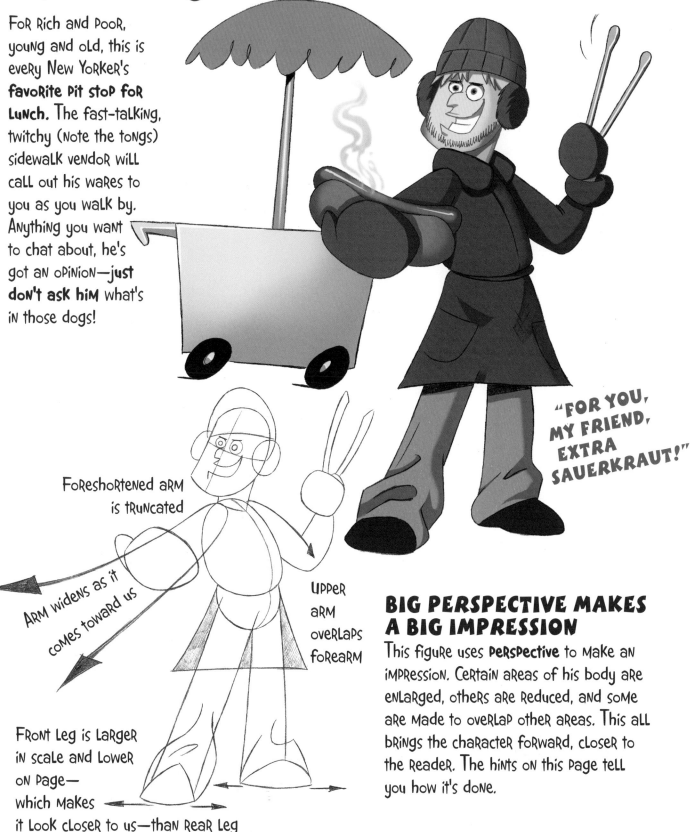

"FOR YOU, MY FRIEND, EXTRA SAUERKRAUT!"

FORESHORTENED ARM is TRUNCATED

ARM WIDENS AS IT COMES TOWARD US

UPPER ARM OVERLAPS FOREARM

FRONT LEG is LARGER IN SCALE AND LOWER ON PAGE—which MAKES it LOOK CLOSER TO US—THAN REAR LEG

BIG PERSPECTIVE MAKES A BIG IMPRESSION

This figure uses **perspective** to make an impression. Certain areas of his body are enlarged, others are reduced, and some are made to overlap other areas. This all brings the character forward, closer to the reader. The hints on this page tell you how it's done.

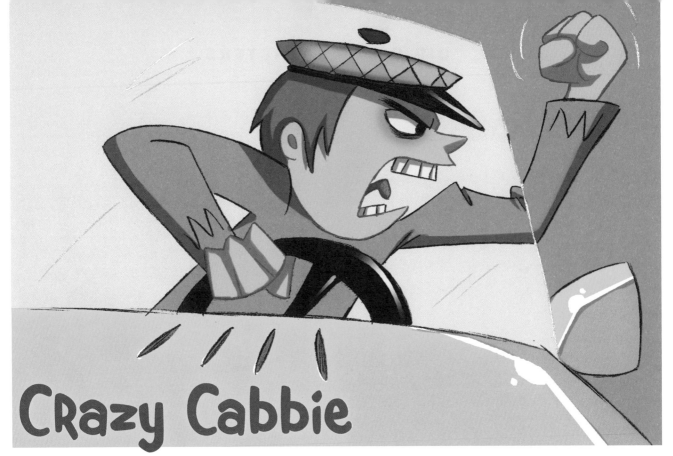

Crazy Cabbie

It's safe to say that New York City's taxi fleet is manned by a lot of people who quit their anger-management therapy a few sessions too early. But these **hot-tempered maniacs** are a riot in cartoons, because they have no qualms about taking their eyes off the road, gesturing wildly and screaming their brains out. All New York pedestrians understand that they must yield to taxi drivers when crossing streets.

A raised shoulder shows tension

Classic cabby wears a flat cap

Fist rises above head for emphasis

Character leans toward the object of his rage

Curl lower lip back for extreme emotion

Corporate Mom

The second this mom's high heels clack onto the pavement—**Look out!** She's not **the cuddliest mom,** but she's certainly efficient. She'll make sure that everyone in the family, including the dog, gets everything done on her checklist before she comes home at night, or there will be heck to pay. And if you think she's fun to be around at home, **just wait** until you work for her.

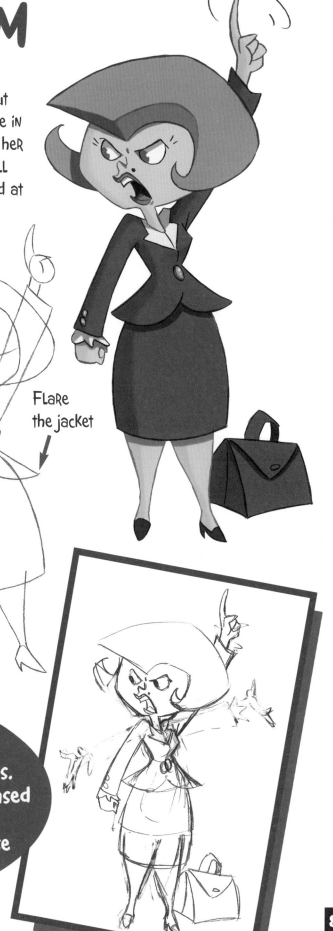

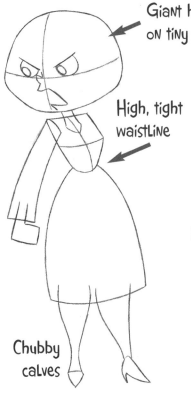

Giant head on tiny neck

High, tight waistline

Chubby calves

Give the hair a back-flip

Flare the jacket

ROUGH SKETCHING

As I first sketched this character, I drew her arms in different positions. You can see the ghost marks that I erased before settling on the final rough sketch. Allow yourself to draw loose and rough at first.

85

The Straphanger

Where else can you find a **multimillionaire** and a **homeless person** sharing a train ride? In New York, both Wall Street titans and the most unfortunate residents take the subway.

The commuter's body leans to the left, swaying with the motion of the train. If you were to draw him standing straight up, the scene would look quite static.

Rectangle for body

Angle of pant hems

Shoulder material bunches sharply on suit

Sketch center line

SHARP DRESSER
Center line is an important guide when drawing the tie, collar and lapel

COMPOSITION DETAILS

The thing that pulls this composition together and makes it fun is the newspapers on opposite corners of the panel. Our **eye automatically connects similar objects**, emphasizing the irony of the scene. Notice that the foreground figure is drawn with a heavier outline than the background figure. If both were drawn with the same thickness of line, they could appear to be on the **same plane**, which they are not.

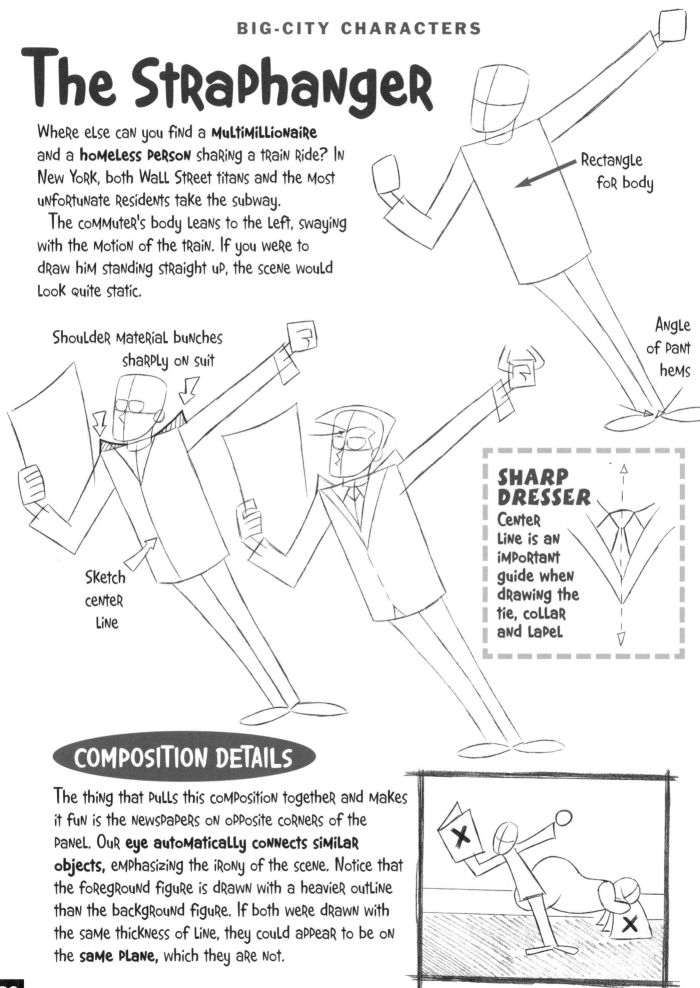

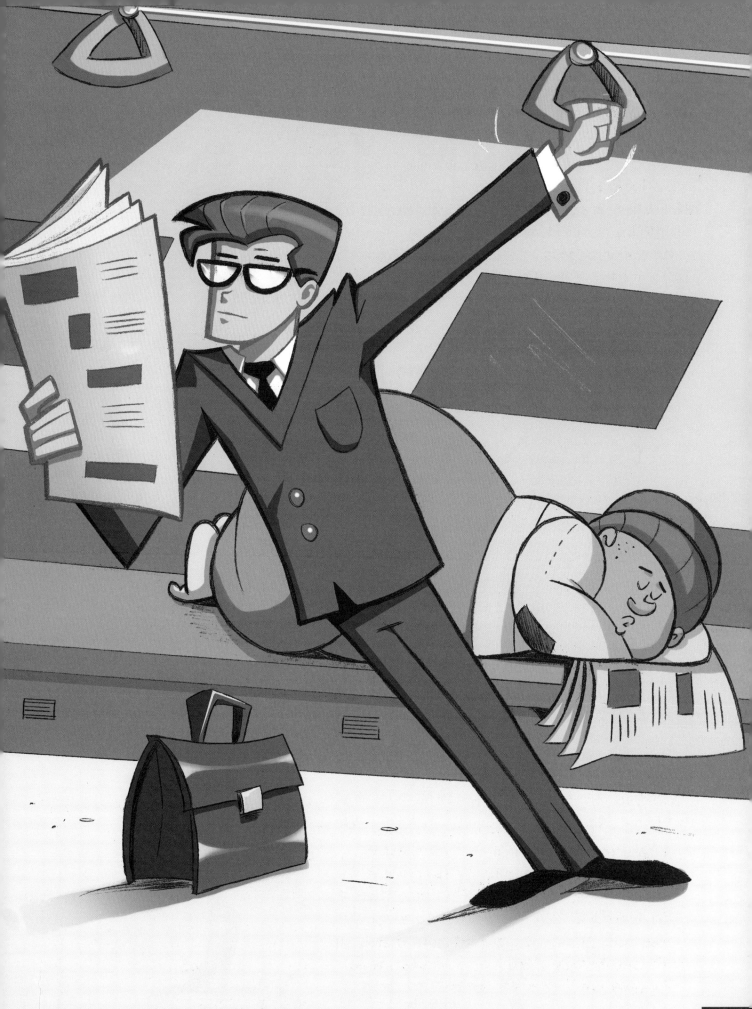

Seventh Avenue Fashion Model

With her **posture so straight** that you could measure a ruler against it, the fashion model is a fashion plate. From her hair to her purse, everything ties in to make a bold style statement.

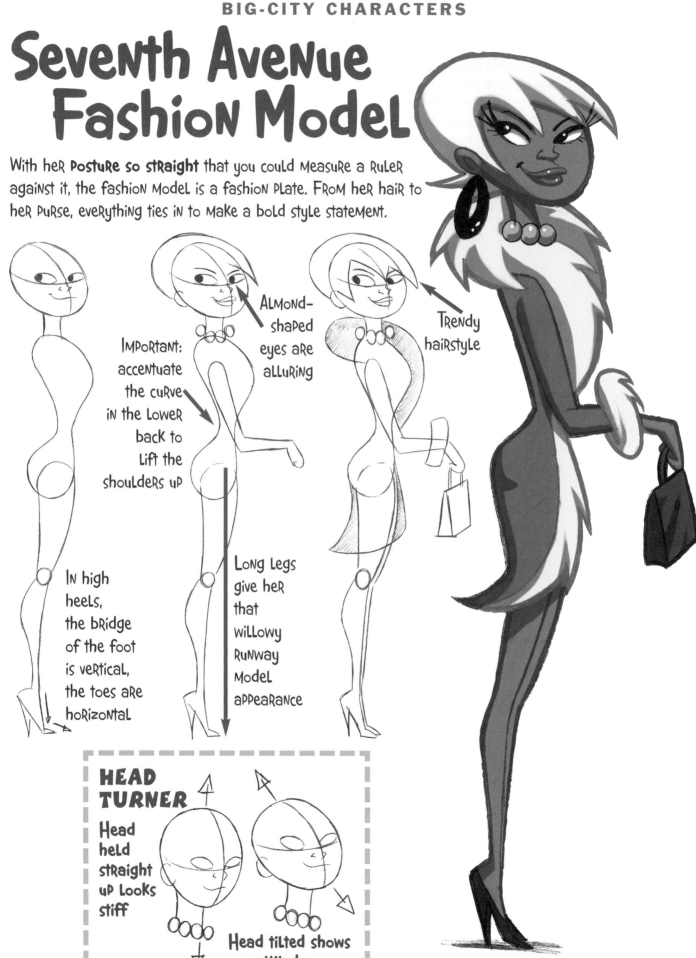

Almond-shaped eyes are alluring

IMPORTANT: accentuate the curve in the lower back to lift the shoulders up

Trendy hairstyle

In high heels, the bridge of the foot is vertical, the toes are horizontal

Long legs give her that willowy runway model appearance

HEAD TURNER

Head held straight up looks stiff

Head tilted shows attitude

Downtown Artist

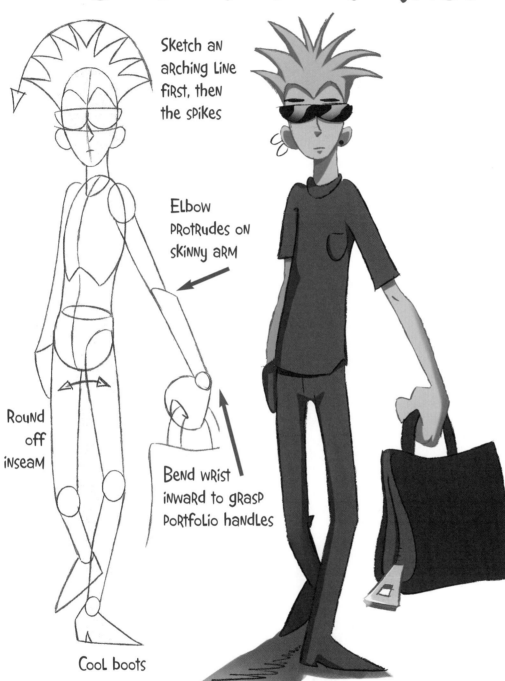

Sketch an arching line first, then the spikes

Elbow protrudes on skinny arm

Round off inseam

Bend wrist inward to grasp portfolio handles

Cool boots

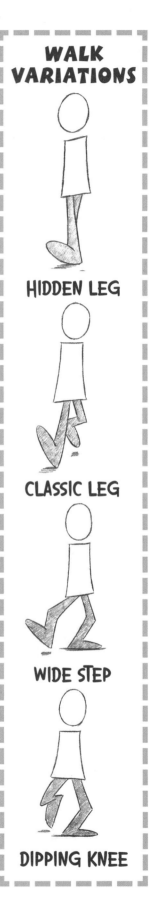

WALK VARIATIONS

HIDDEN LEG

CLASSIC LEG

WIDE STEP

DIPPING KNEE

Black sunglasses, **black** shirt, **black** pants and a **black** portfolio: this guy is **hip.** He's tall and thin, not too robust and he has a slinky posture. He's delivering his assignment on foot—because he isn't getting paid enough to take the subway.

Speaking of walking...while it's relatively easy to draw a side view of someone walking (since you can clearly see what each part of the body is doing), a front view can be a little trickier. On the right are a few variations for you to choose from.

Do-Rag Guy

Here's a popular **city look.** The do-rag often covers a shaved head or all of the hair underneath; however, in cartooning, it's also a good look to allow some of the hair to peek out, as shown here. I like to float the knot tied in the back—**a curious phenomenon** you can only create with a pencil.

The overall shape of the folded arms widens as it approaches the reader

Baggy pants and an oversized shirt are a typical combo

Draw the do-rag on one side, not on the top of his head

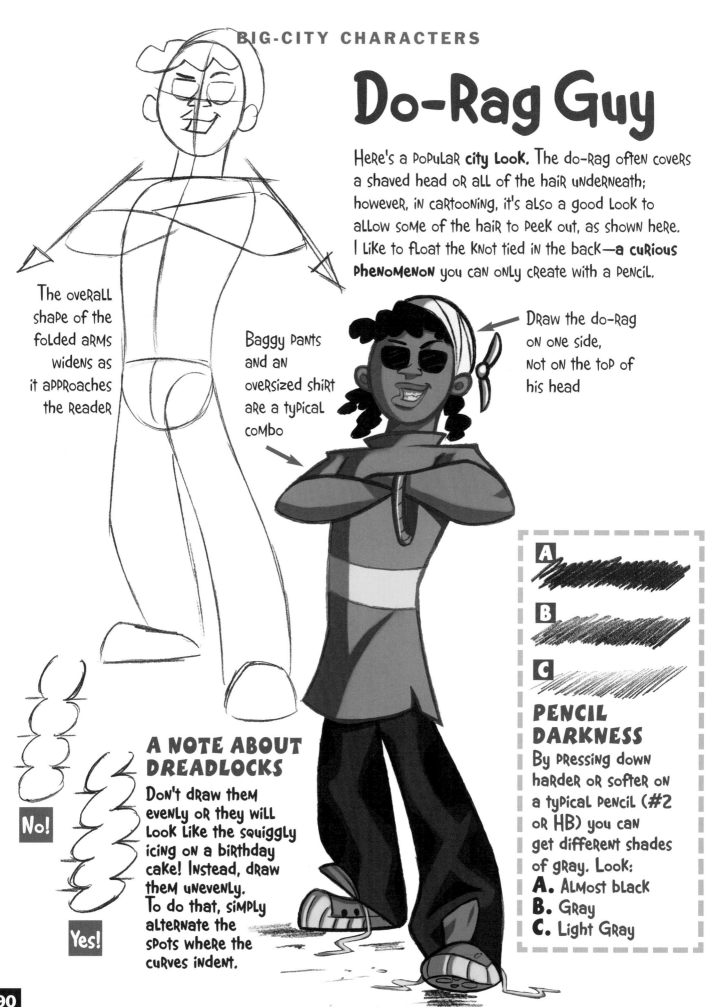

A NOTE ABOUT DREADLOCKS

Don't draw them evenly or they will look like the squiggly icing on a birthday cake! Instead, draw them unevenly. To do that, simply alternate the spots where the curves indent.

No!

Yes!

A

B

C

PENCIL DARKNESS

By pressing down harder or softer on a typical pencil (#2 or HB) you can get different shades of gray. Look:
A. Almost black
B. Gray
C. Light Gray

The Latte Fiend

She's using her trust fund wisely—to endow a permanent chair at the **local hip cafe.** No need to worry about making small talk with her. She will **yak and yak and yak**—that's her fifteenth Mocha Latte this morning. Look at that posture. Whoa! She's on high alert, just **brimming with energy.** Characters who talk a mile a minute are major-league funny, because they're hyper to the max.

Our gal's short hair is a **chic, big-city style,** as is her outfit. You wouldn't draw her this way if you were doing, for instance, a typical Midwestern character.

Props are funny, too! We can also caricature the props in a scene—in this case, the table and chair. By making their legs single lines, we poke fun at the measly proportions and also give them a retro style.

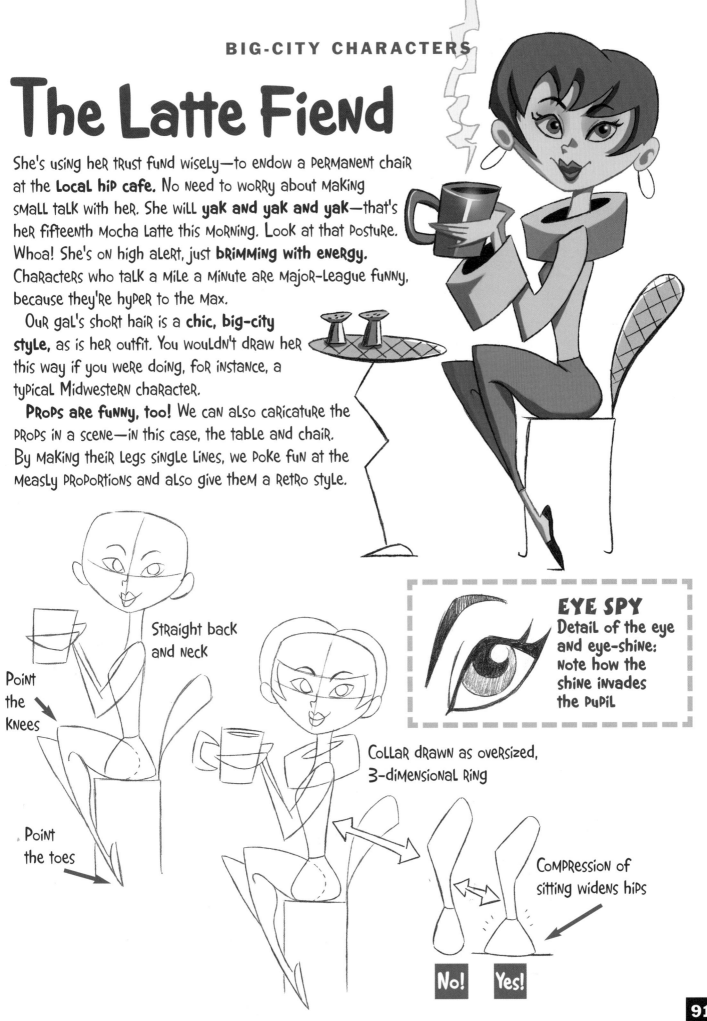

Straight back and neck

Point the knees

Point the toes

Collar drawn as oversized, 3-dimensional ring

EYE SPY
Detail of the eye and eye-shine: Note how the shine invades the pupil

Compression of sitting widens hips

No! Yes!

The Dog Walker

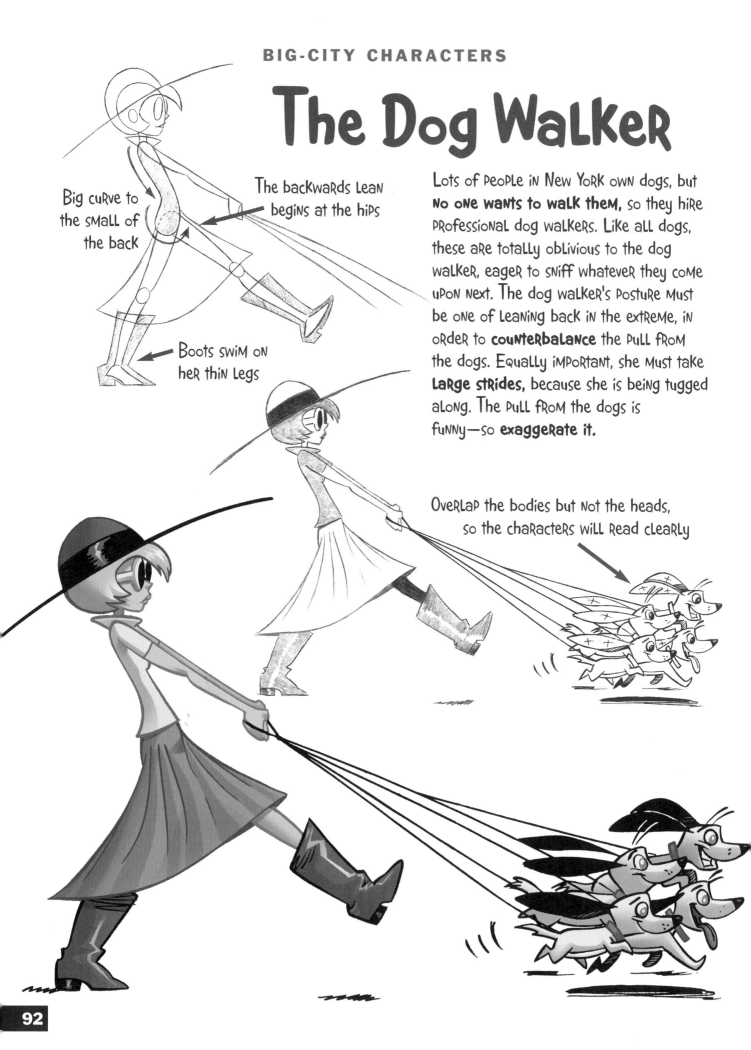

Big curve to the small of the back

The backwards lean begins at the hips

Boots swim on her thin legs

Lots of people in New York own dogs, but **no one wants to walk them,** so they hire professional dog walkers. Like all dogs, these are totally oblivious to the dog walker, eager to sniff whatever they come upon next. The dog walker's posture must be one of leaning back in the extreme, in order to **counterbalance** the pull from the dogs. Equally important, she must take **large strides,** because she is being tugged along. The pull from the dogs is funny—so **exaggerate it.**

Overlap the bodies but not the heads, so the characters will read clearly

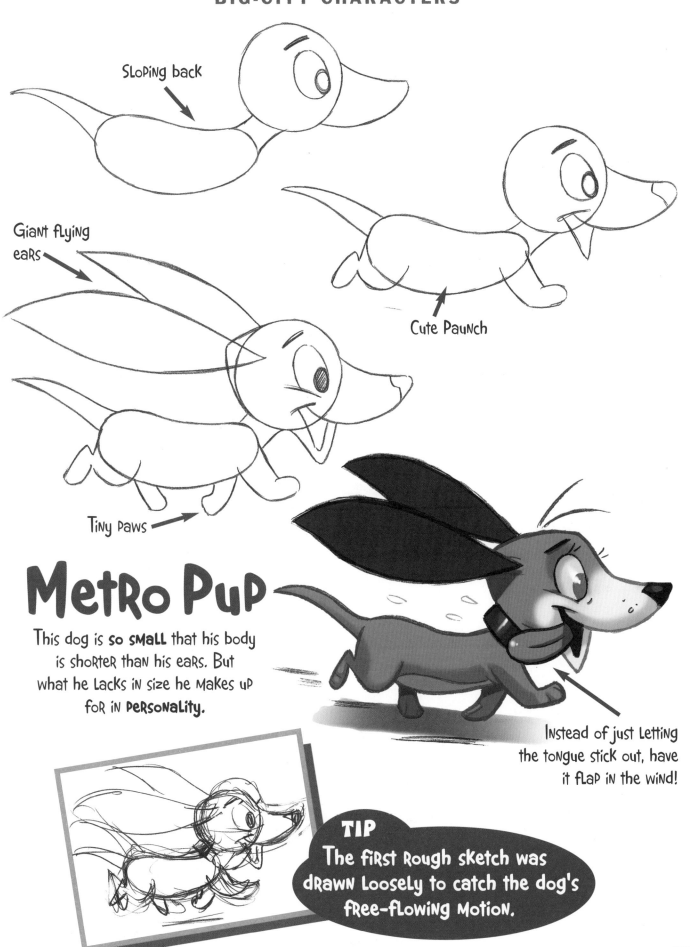

Sloping back

Giant flying ears

Cute Paunch

Tiny paws

Metro Pup

This dog is **so small** that his body is shorter than his ears. But what he lacks in size he makes up for in **personality**.

Instead of just letting the tongue stick out, have it flap in the wind!

TIP
The first rough sketch was drawn loosely to catch the dog's free-flowing motion.

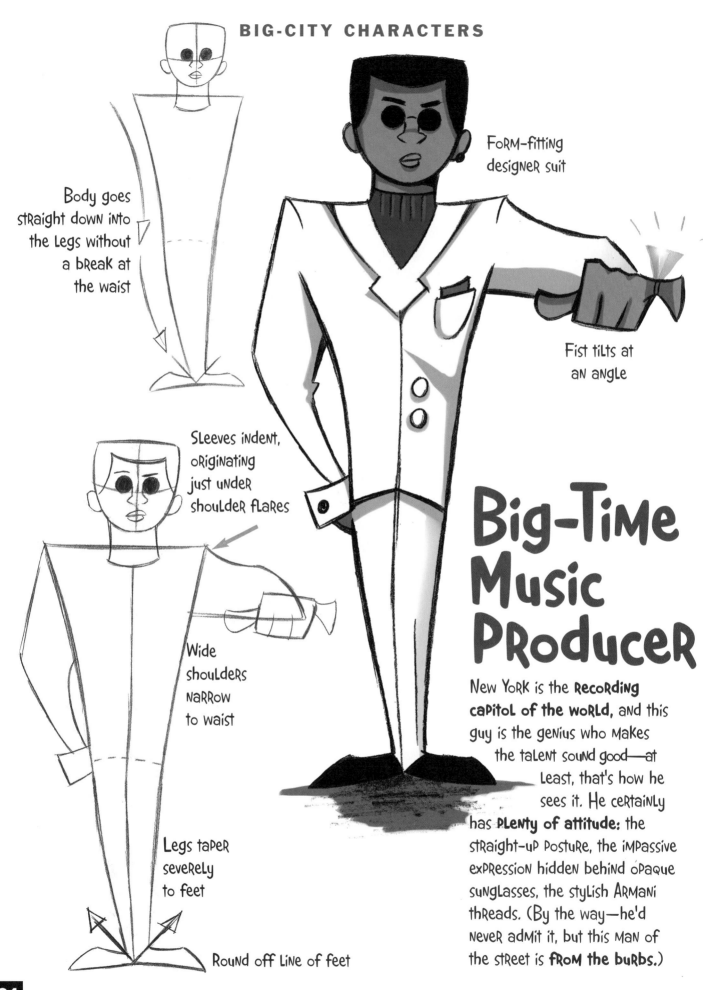

Body goes straight down into the legs without a break at the waist

Form-fitting designer suit

Fist tilts at an angle

Sleeves indent, originating just under shoulder flares

Wide shoulders narrow to waist

Legs taper severely to feet

Round off line of feet

Big-Time Music Producer

New York is the **recording capitol of the world,** and this guy is the genius who makes the talent sound good—at least, that's how he sees it. He certainly has **plenty of attitude:** the straight-up posture, the impassive expression hidden behind opaque sunglasses, the stylish Armani threads. (By the way—he'd never admit it, but this man of the street is **from the burbs.**)

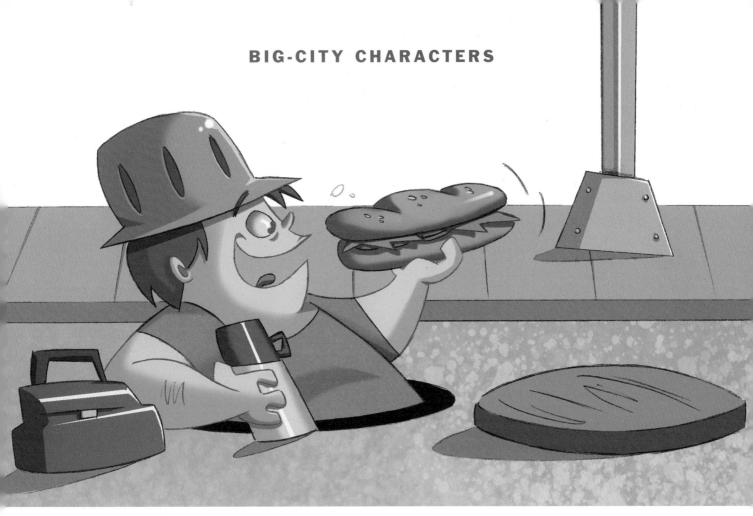

Sewer Worker

Popping out of a **manhole** in the ground is the hardy city sewer worker. The cartoon style portrays him as a **hefty but gregarious guy,** and not the snappiest of dressers. He has big jowls and a wide mouth.

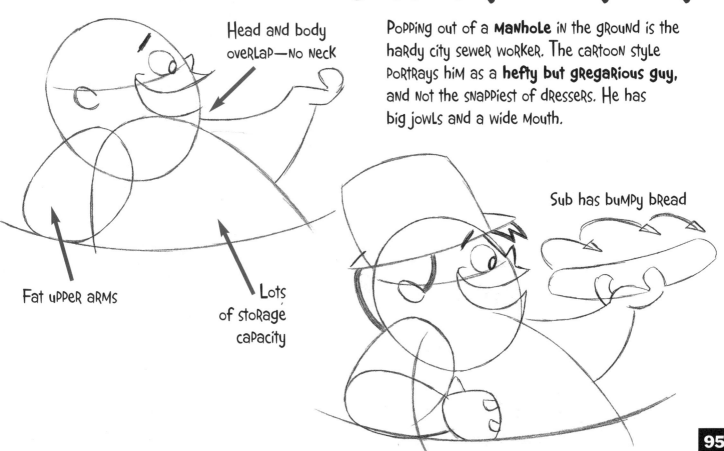

Head and body overlap—no neck

Fat upper arms

Lots of storage capacity

Sub has bumpy bread

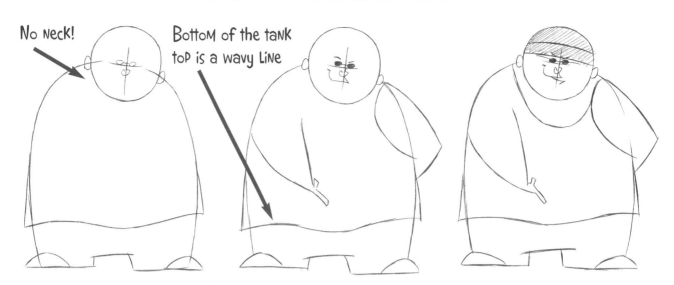

No neck!

Bottom of the tank top is a wavy line

Street Merchant

Want a watch for **only five bucks?** You came to the right place! These guys are on every corner, selling everything from mink coats to alligator wallets.

This character is a **hoot to draw**— and easy, because he's based on large overall shapes.

LIP SERVICE
The bottom lip juts out past the chin, which is typical of fat characters

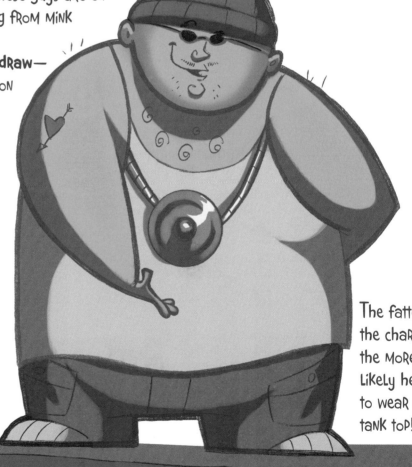

The fatter the character, the more likely he is to wear a tank top!

New York Guard Dog

If I've **gotta** pick a breed for this city, I'm gonna have to go with the German shepherd. Ever the guard dog, the shepherd's ears are perked up in a ready position. He's not cuddly or charming—he's a **can of pepper spray on four legs.**

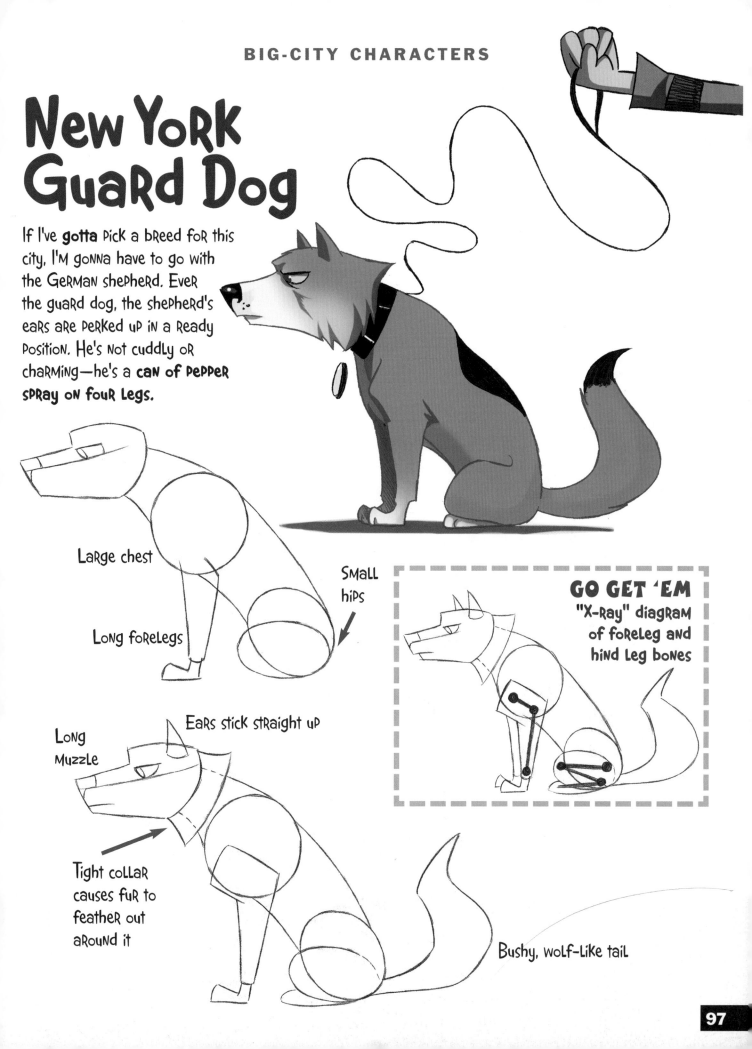

Large chest

Long forelegs

Small hips

GO GET 'EM
"X-ray" diagram of foreleg and hind leg bones

Ears stick straight up

Long Muzzle

Tight collar causes fur to feather out around it

Bushy, wolf-like tail

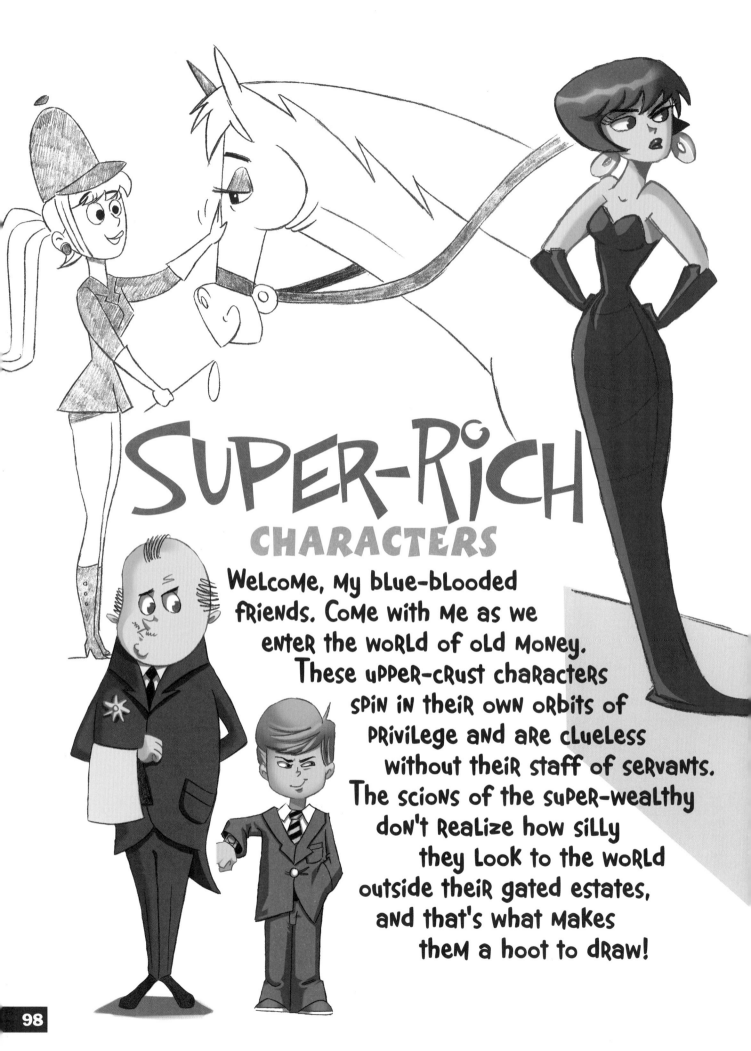

SUPER-RICH
CHARACTERS

Welcome, my blue-blooded friends. Come with me as we enter the world of old money. These upper-crust characters spin in their own orbits of privilege and are clueless without their staff of servants. The scions of the super-wealthy don't realize how silly they look to the world outside their gated estates, and that's what makes them a hoot to draw!

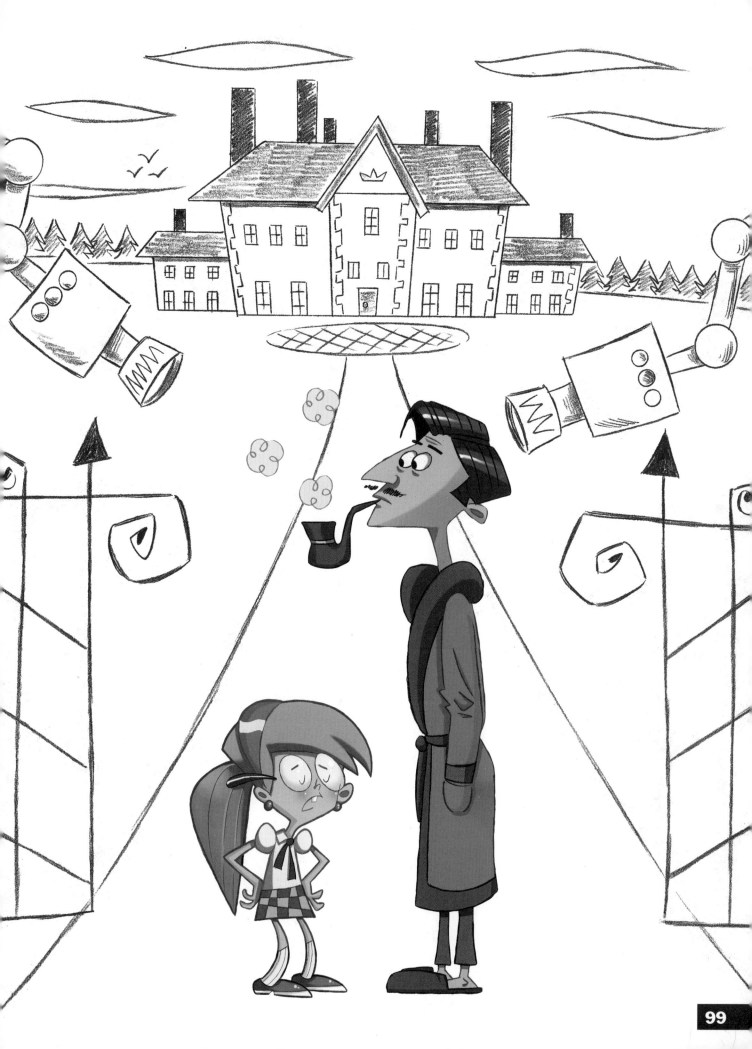

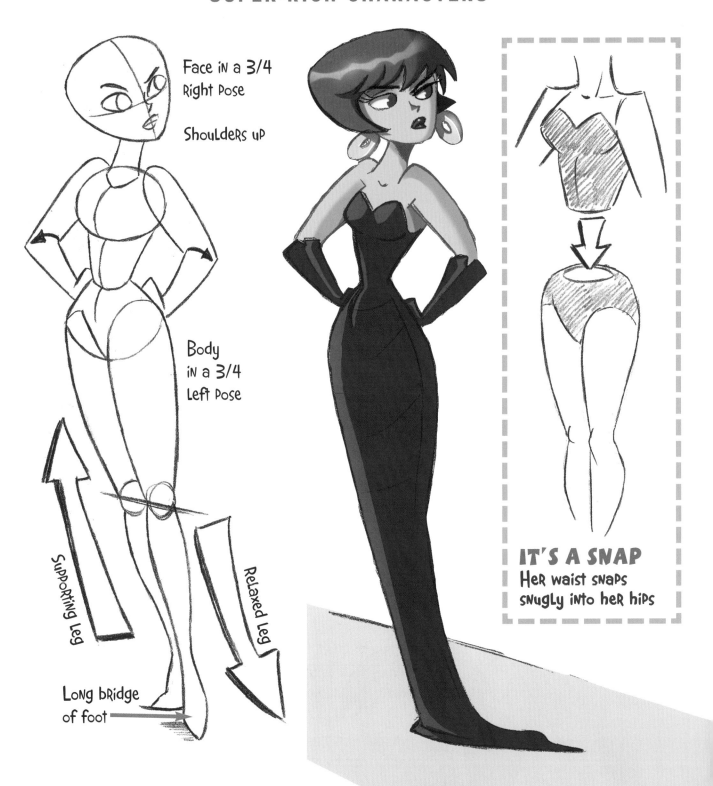

Face in a 3/4 Right Pose

Shoulders up

Body in a 3/4 Left Pose

Supporting Leg

Relaxed Leg

Long bridge of foot

IT'S A SNAP
Her waist snaps snugly into her hips

Rich Witch

The **richer** the character, the more **self-conscious** his or her pose must be.
Every hand gesture, point of the foot and tilt of the shoulder says **"I'm better than you."**
Therefore, the head is held high, with a regal air.

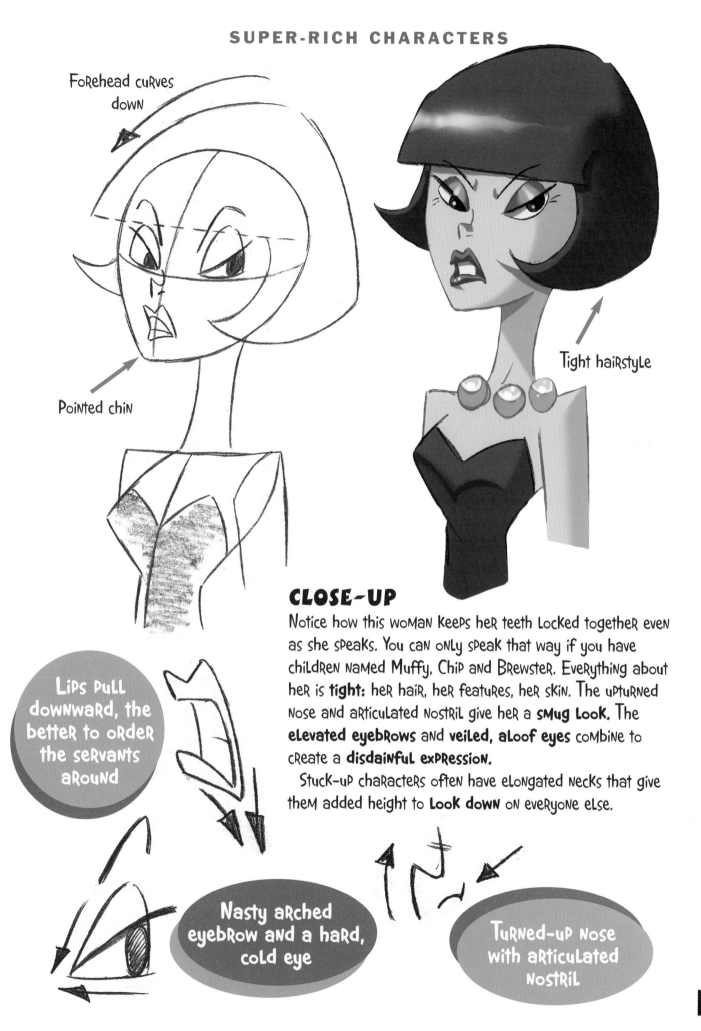

Forehead curves down

Pointed chin

Tight hairstyle

CLOSE-UP

Notice how this WOMAN keeps her teeth locked together even as she speaks. You can only speak that way if you have children named Muffy, Chip and Brewster. Everything about her is **tight:** her hair, her features, her skin. The upturned nose and articulated nostril give her a **smug look.** The **elevated eyebrows** and **veiled, aloof eyes** combine to create a **disdainful expression.**

Stuck-up characters often have elongated necks that give them added height to **look down** on everyone else.

Lips pull downward, the better to order the servants around

Nasty arched eyebrow and a hard, cold eye

Turned-up nose with articulated nostril

Rich Dad

Here's Dad, **confused as usual.** When his assets passed the **$100 million mark**, he suddenly became an idiot. It's the Law of Cartoon Super-Wealth.

The smoking jacket is really just a **fancy bathrobe.** The jaunty chin is a cartooning sign of **good breeding** and **low intelligence.**

Eyes on same side of head for a goofy look

Jaunty chin

Waistband pulls in

Hands fit comfortably in large pockets

Pants stop above ankles

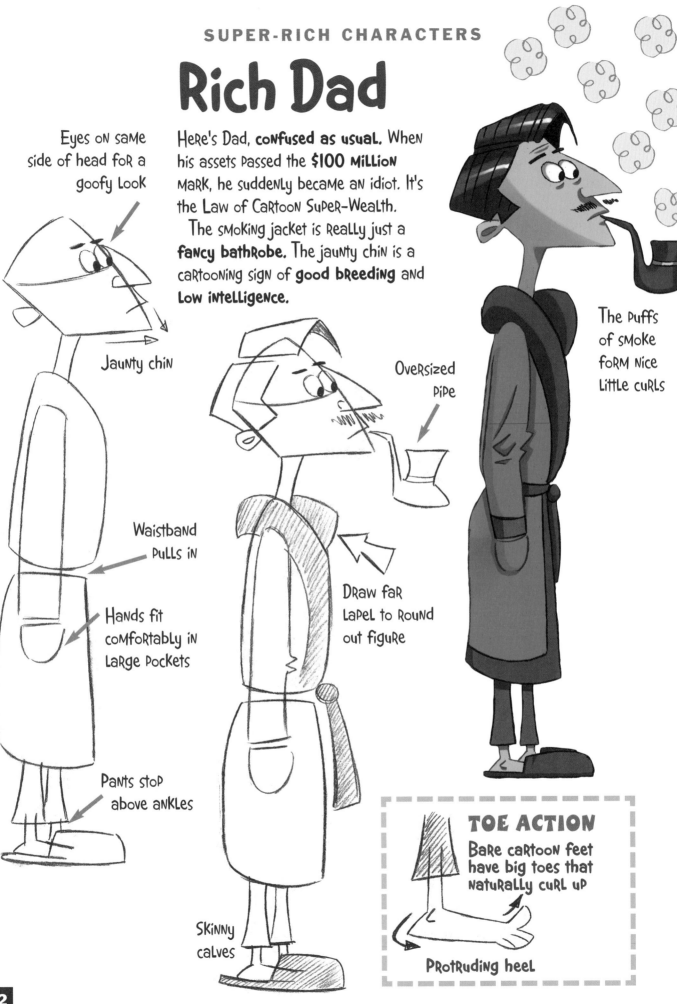

Oversized pipe

Draw far lapel to round out figure

Skinny calves

The puffs of smoke form nice little curls

TOE ACTION

Bare cartoon feet have big toes that naturally curl up

Protruding heel

Spoiled Teen Girl

When adolescence calls, a young girl's legs suddenly spring up ahead of the rest of her body. **This kid's got attitude:** her arms seem to be fused in the akimbo position, the classic hands-on-hips pose that says **"No one understands how hard my life is."** This body tilt screams indignation. It's a classic counterbalanced posture: the body leans in one direction, the head tilts in the other.

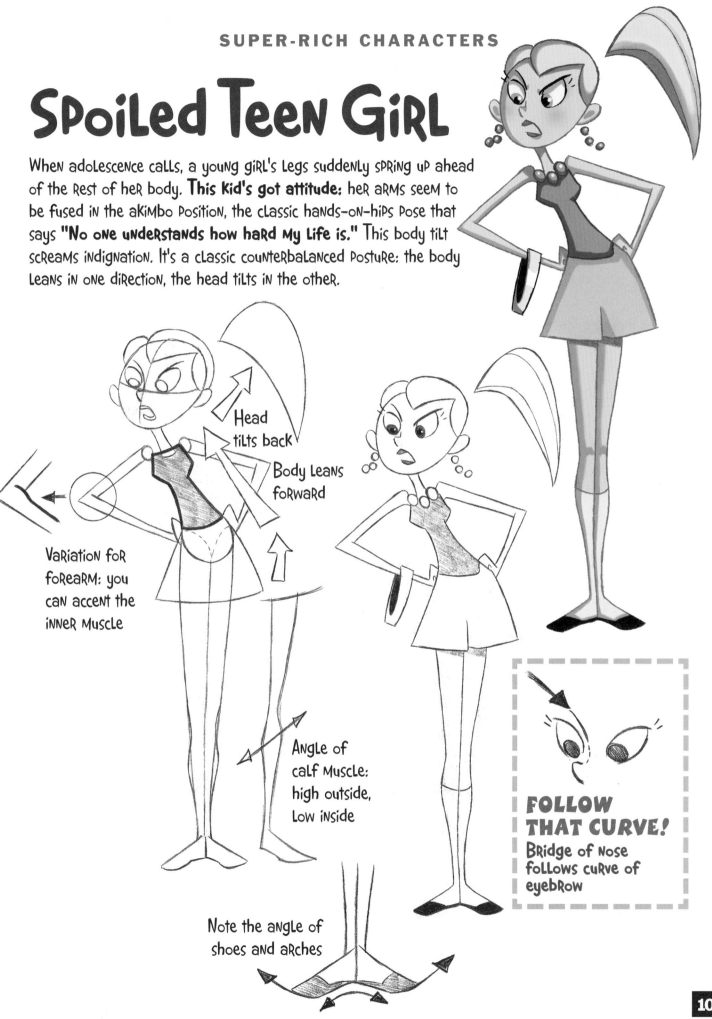

Head tilts back

Body leans forward

Variation for forearm: you can accent the inner muscle

Angle of calf muscle: high outside, low inside

Note the angle of shoes and arches

FOLLOW THAT CURVE! Bridge of nose follows curve of eyebrow

103

The PRep School BRat

Give this **future CEO** a starched collar, a tie and a sweater vest. He should look like a little man—or a **little dictator**, to be more accurate. But he'll have to finish school before he can **inherit the family business** and lay off 5,000 workers.

Mean little eyebrows

Tight, starched collar

Hips, not just legs

Let those ears flap

ARM continues line of torso

Extend the front leg

The Little Angel

This little angel is as sweet as sugar and can't do anything wrong—at least that's the impression she wants to give. The truth is **very far** from that. She should be dressed neat and tidy with a big bow, a ponytail or pigtails-things that make her look sweet. I've given her an enormous head to draw attention to all those evil thoughts she's having. She's got a **cherubic face** but **an insincere smile.**

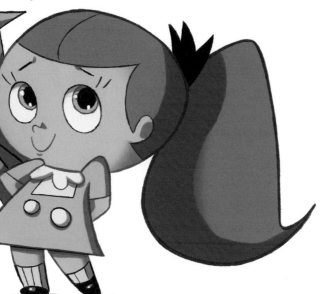

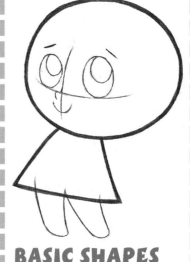

BASIC SHAPES

For a retro look, build the character out of basic shapes

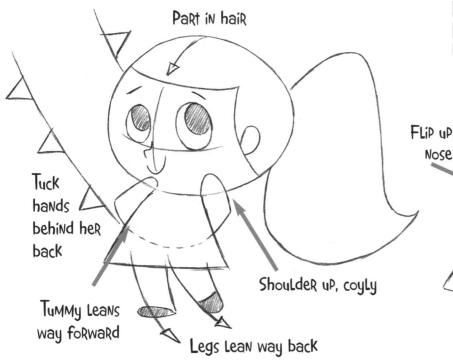

Part in hair

Tuck hands behind her back

Tummy leans way forward

Shoulder up, coyly

Legs lean way back

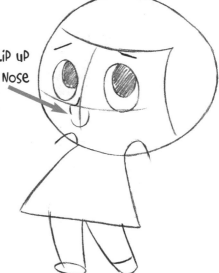

Flip up nose

MasteR of The UniveRse, JunioR Edition

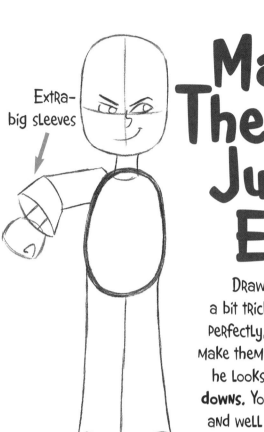

Extra-big sleeves

Well-gRoomed

SharP cReases in shouldeRs of suit

DRawing a **Rich kid in a suit** is a bit tRicky. If you make his clothes fit peRfectly, he doesn't look funny. If you make them extRemely loose and oveRsized, he looks like he's weaRing **hand-me-downs.** You want his suit to look tailoRed and well made but half a size too big. He'll gRow into it—like he'll gRow into his dad's seat on the **FoRtune 500 company's** boaRd.

Pants buckle at bottom, just above shoes

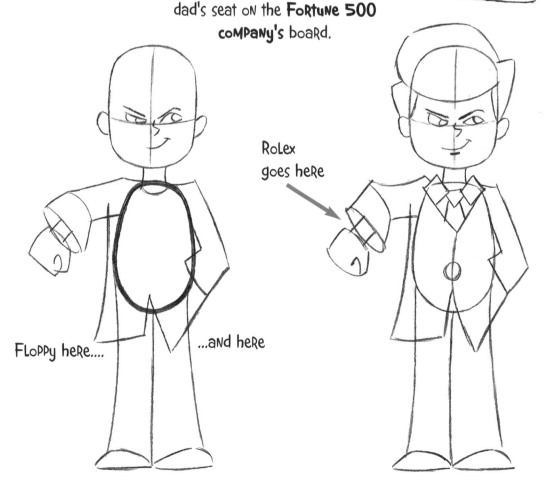

Floppy heRe....

...and heRe

Rolex goes heRe

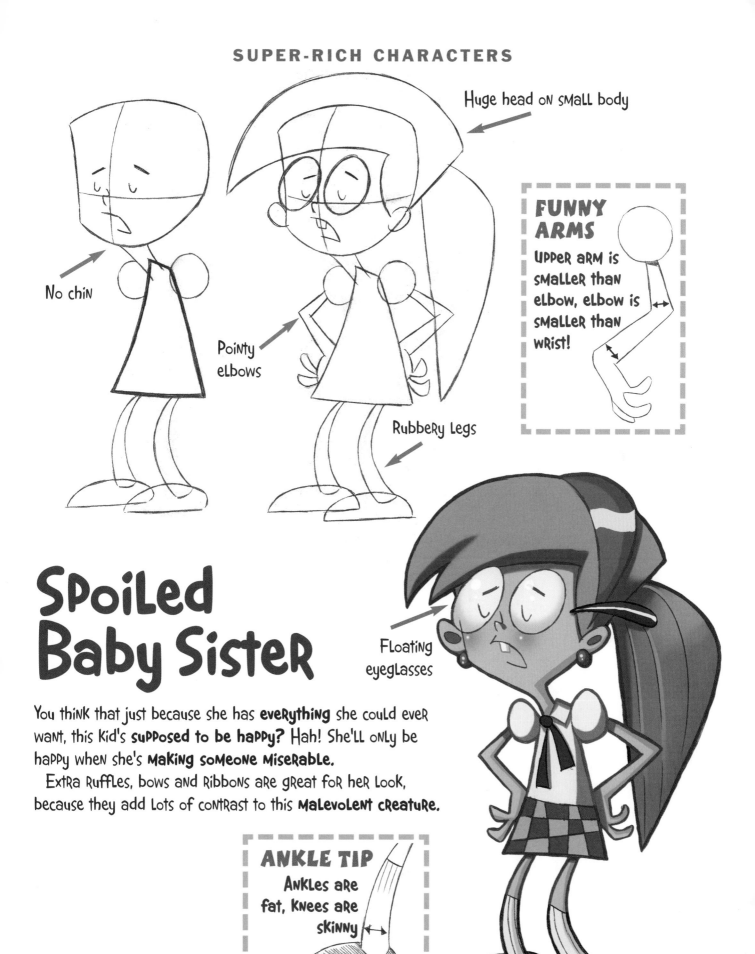

Huge head on small body

No chin

Pointy elbows

Rubbery Legs

FUNNY ARMS

Upper arm is smaller than elbow, elbow is smaller than wrist!

Spoiled Baby Sister

You think that just because she has **everything** she could ever want, this kid's **supposed to be happy?** Hah! She'll only be happy when she's **making someone miserable.**

Extra ruffles, bows and ribbons are great for her look, because they add lots of contrast to this **malevolent creature.**

Floating eyeglasses

ANKLE TIP

Ankles are fat, knees are skinny

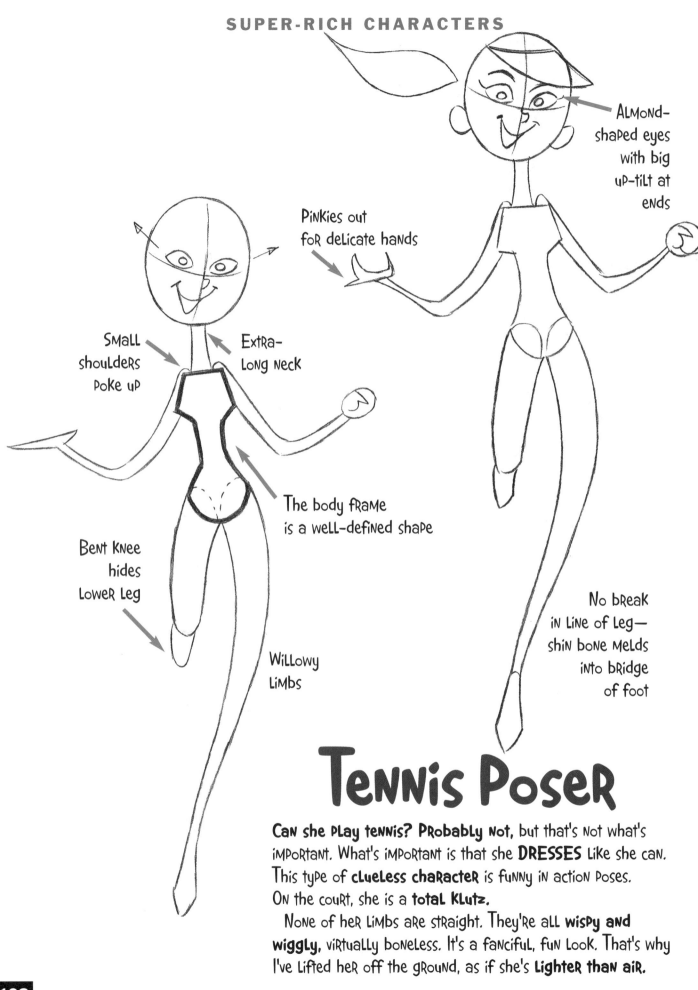

Almond-shaped eyes with big up-tilt at ends

Pinkies out for delicate hands

Small shoulders poke up

Extra-long neck

The body frame is a well-defined shape

Bent knee hides Lower Leg

Willowy Limbs

No break in Line of Leg— shin bone melds into bridge of foot

Tennis Poser

Can she play tennis? Probably not, but that's not what's important. What's important is that she **DRESSES** like she can. This type of **clueless character** is funny in action poses. On the court, she is a **total klutz.**

None of her limbs are straight. They're all **wispy and wiggly**, virtually boneless. It's a fanciful, fun look. That's why I've lifted her off the ground, as if she's **lighter than air.**

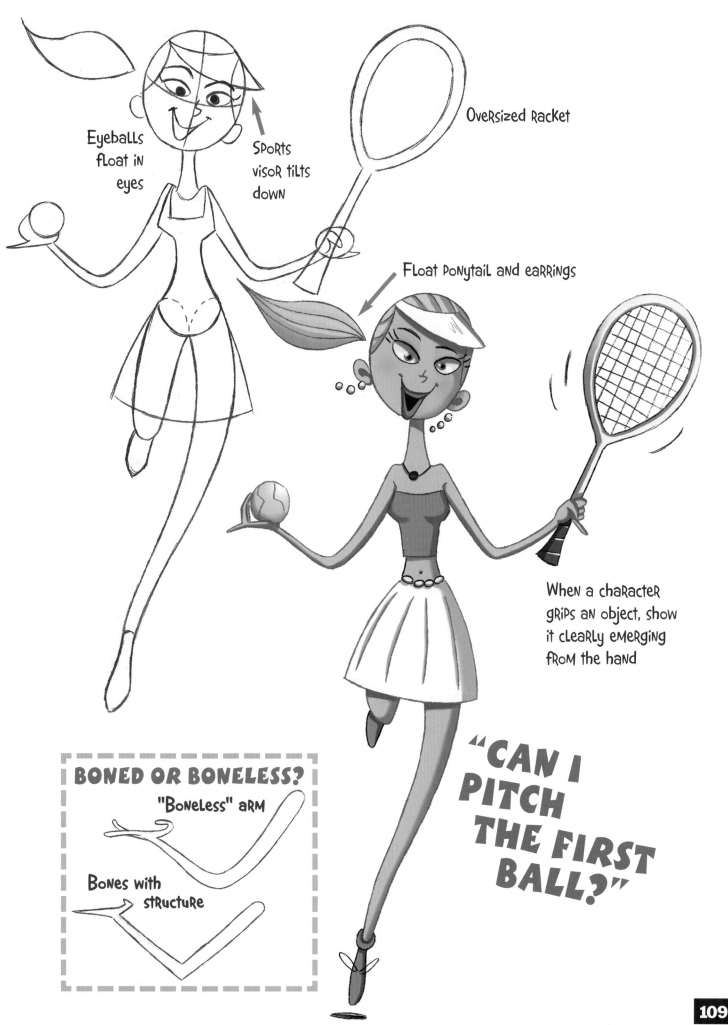

Eyeballs float in eyes

Sports visor tilts down

Oversized Racket

Float ponytail and earrings

When a character grips an object, show it clearly emerging from the hand

"CAN I PITCH THE FIRST BALL?"

BONED OR BONELESS?

"Boneless" arm

Bones with structure

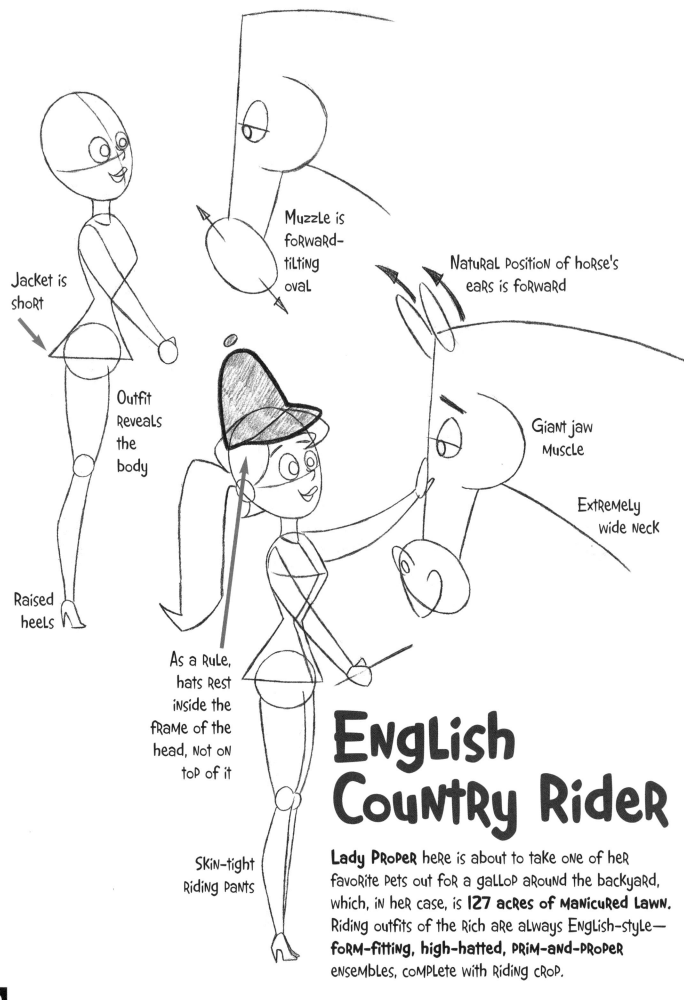

Jacket is short

Muzzle is forward-tilting oval

Natural position of horse's ears is forward

Outfit reveals the body

Giant jaw muscle

Extremely wide neck

Raised heels

As a Rule, hats Rest inside the frame of the head, not on top of it

Skin-tight Riding pants

English Country Rider

Lady Proper here is about to take one of her favorite pets out for a gallop around the backyard, which, in her case, is **127 acres of manicured lawn.** Riding outfits of the rich are always English-style— **form-fitting, high-hatted, prim-and-proper** ensembles, complete with riding crop.

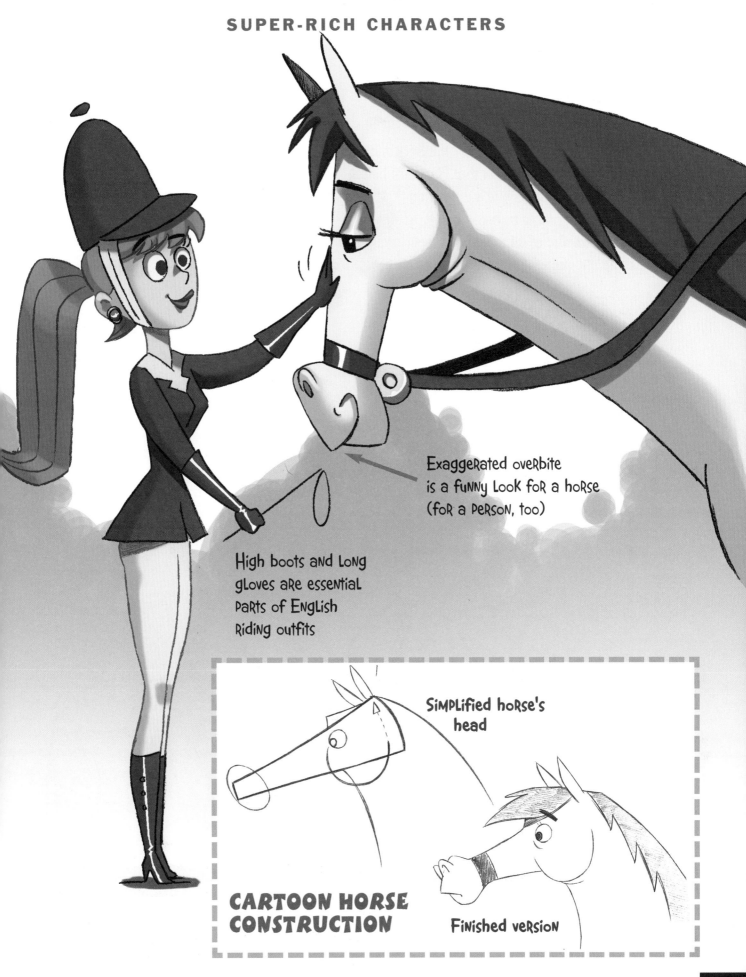

Exaggerated overbite is a funny look for a horse (for a person, too)

High boots and long gloves are essential parts of English riding outfits

Simplified horse's head

CARTOON HORSE CONSTRUCTION

Finished version

Butlers

To be honest, I'm not really sure what the heck a butler actually does (although we know that Batman's butler keeps the Batcave and Batmobile nice and tidy). Is "to butle" a verb? In any case, as a cartoonist, you can't really make proper fun of rich people without giving them a butler. Here are some of my favorite **butler types.**

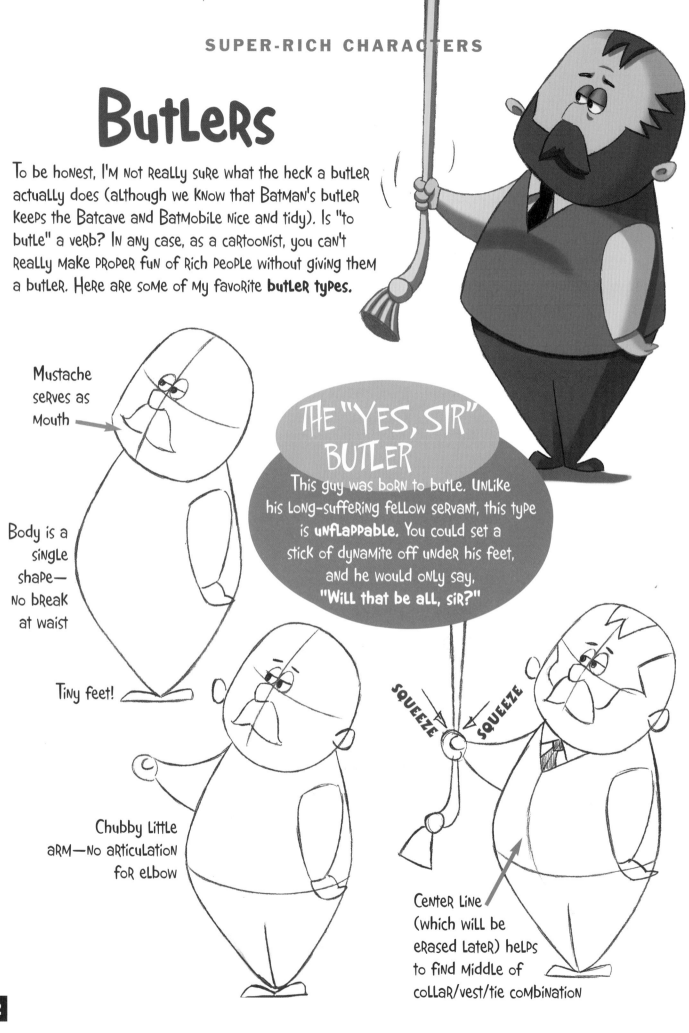

Mustache serves as Mouth

Body is a single shape— no break at waist

Tiny feet!

Chubby little arm—no articulation for elbow

THE "YES, SIR" BUTLER

This guy was born to butle. Unlike his long-suffering fellow servant, this type is **unflappable.** You could set a stick of dynamite off under his feet, and he would only say, **"Will that be all, sir?"**

SQUEEZE SQUEEZE

Center line (which will be erased later) helps to find middle of collar/vest/tie combination

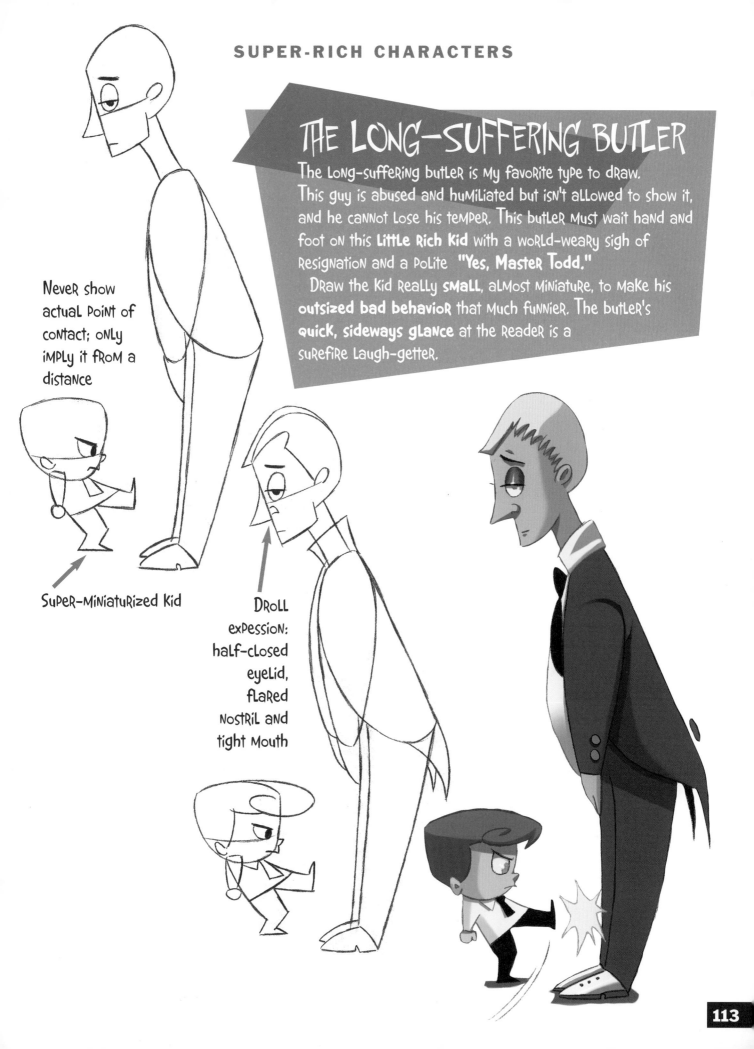

THE LONG-SUFFERING BUTLER

The long-suffering butler is my favorite type to draw. This guy is abused and humiliated but isn't allowed to show it, and he cannot lose his temper. This butler must wait hand and foot on this **little rich kid** with a world-weary sigh of resignation and a polite **"Yes, Master Todd."**

Draw the kid really **small**, almost miniature, to make his **outsized bad behavior** that much funnier. The butler's **quick, sideways glance** at the reader is a surefire laugh-getter.

Never show actual point of contact; only imply it from a distance

Super-Miniaturized kid

Droll expession: half-closed eyelid, flared nostril and tight mouth

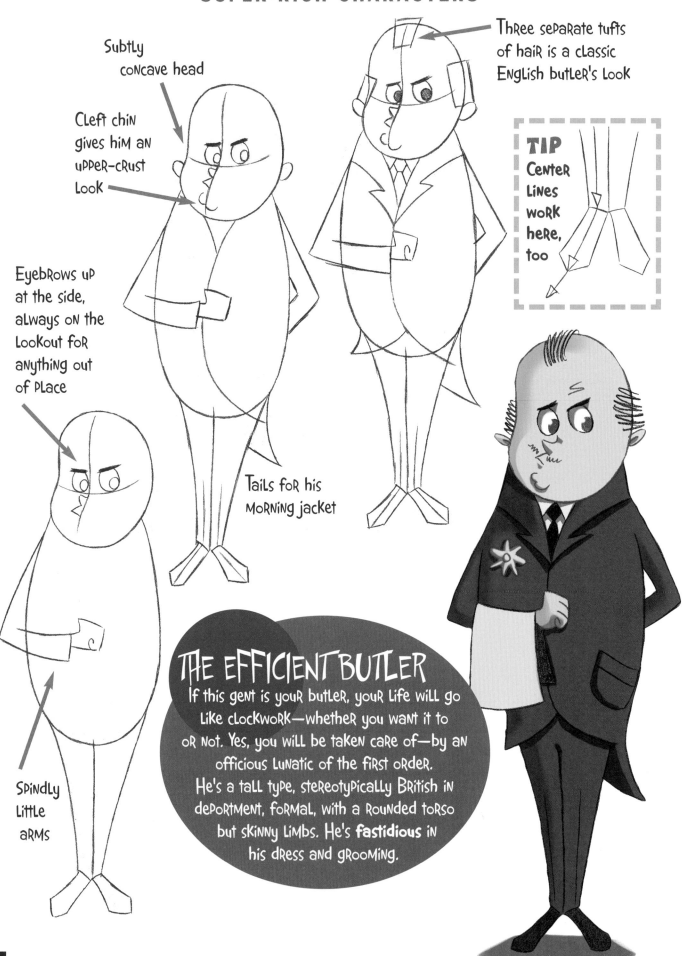

Subtly concave head

Cleft chin gives him an upper-crust look

Three separate tufts of hair is a classic English butler's look

TIP Center lines work here, too

Eyebrows up at the side, always on the lookout for anything out of place

Tails for his morning jacket

Spindly little arms

THE EFFICIENT BUTLER

If this gent is your butler, your life will go like clockwork—whether you want it to or not. Yes, you will be taken care of—by an officious lunatic of the first order. He's a tall type, stereotypically British in deportment, formal, with a rounded torso but skinny limbs. He's **fastidious** in his dress and grooming.

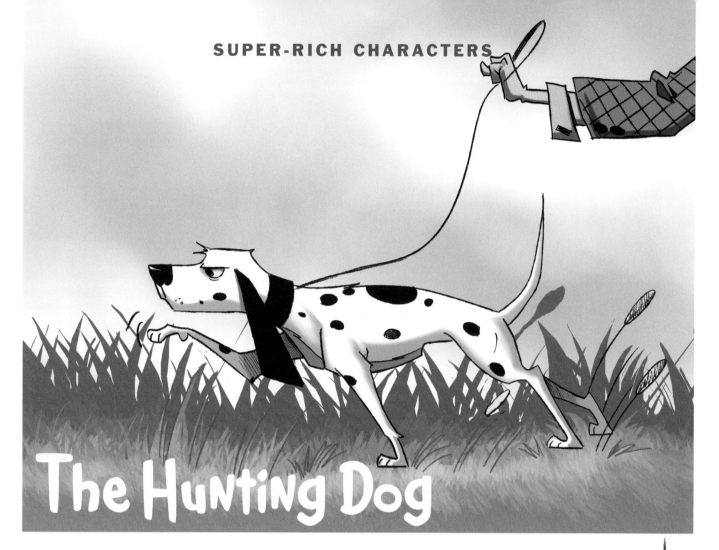

The Hunting Dog

This is a **great gig,** if you're a dog. You could have been a RETRIEVER, slogging through the cold marsh to bring back a duck for your owner. But you're a POINTER, so your job is to **just stand there and point.**

The POINTER has a large chest and narrow hips. He's got a **long nose** and **pendulous ears.** The legs are long and taper to delicate feet. He's a fairly heavy dog, but rather **elegant in his gait.** This drawing shows a simplified configuration of his foreleg and hind leg bones in action.

Very symmetrically shaped head

Note slight curve of the back

Nose and eye are on the same level

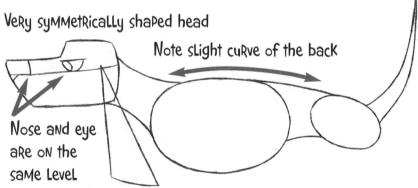

DOG ANATOMY 101

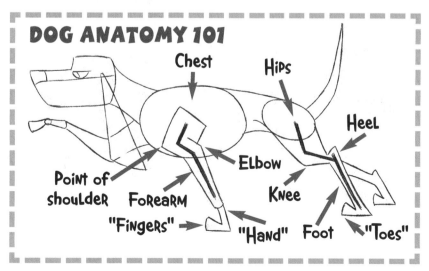

Chest

Hips

Heel

Point of shoulder

Forearm

Elbow

Knee

"Fingers"

"Hand"

Foot

"Toes"

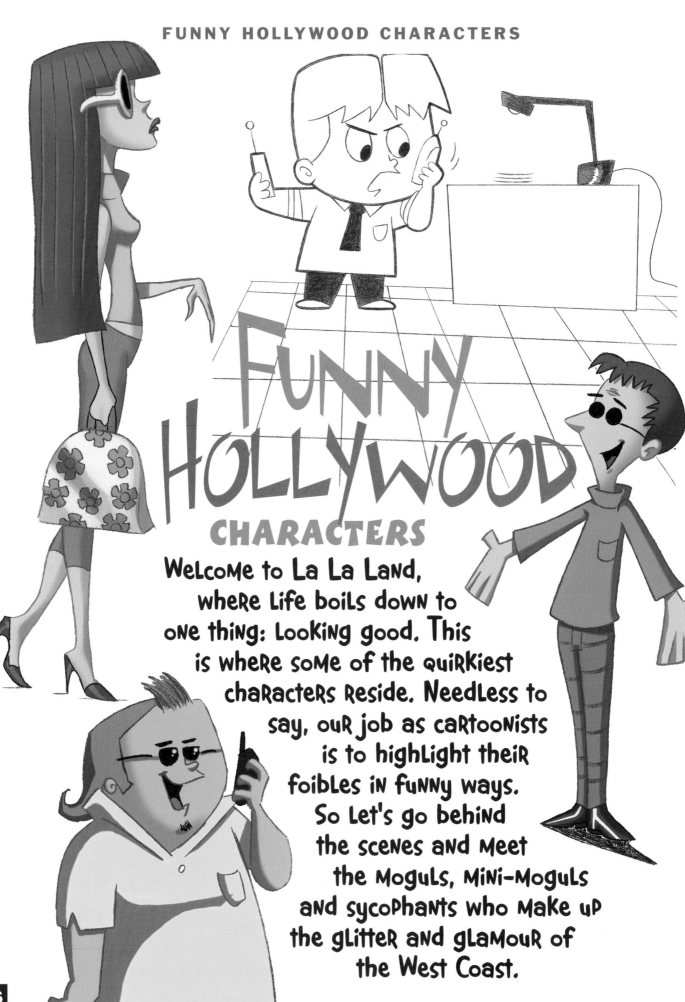

FUNNY HOLLYWOOD CHARACTERS

Welcome to La La Land, where life boils down to one thing: Looking good. This is where some of the quirkiest characters reside. Needless to say, our job as cartoonists is to highlight their foibles in funny ways. So let's go behind the scenes and meet the moguls, mini-moguls and sycophants who make up the glitter and glamour of the West Coast.

Movie Producer

If you want to **produce movies**, you've got to be 50 pounds overweight and not realize it. You also have to wear **sunglasses**, whether the sun is out or not. Or even if it's nighttime. Also, the balder you get, the longer you grow your hair in back. And one more thing: you must talk on your **cell phone** continuously, no matter what.

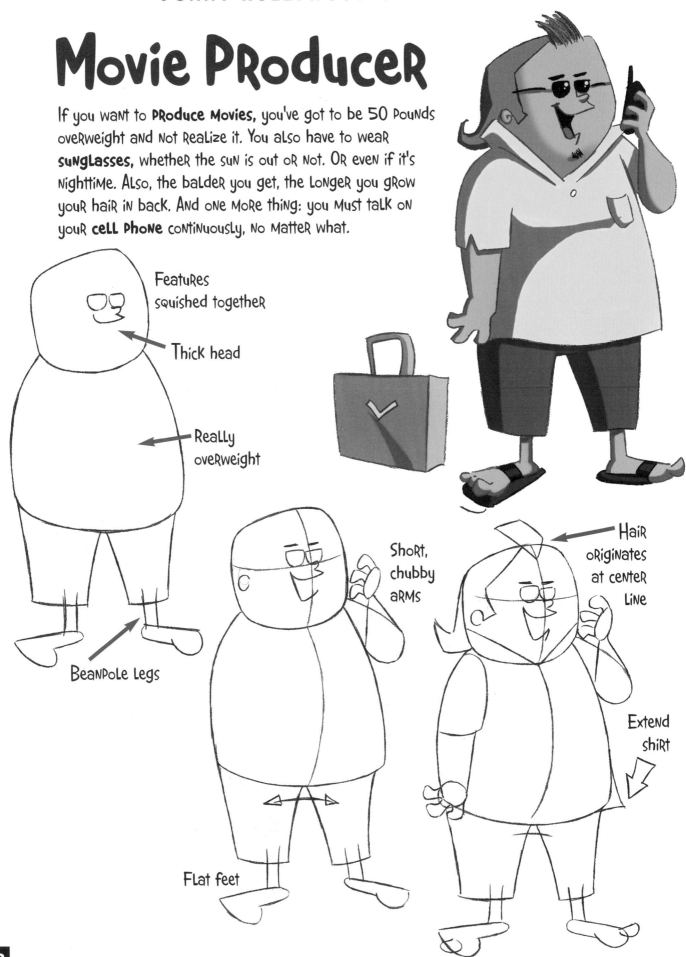

Features squished together

Thick head

Really overweight

Beanpole legs

Short, chubby arms

Flat feet

Hair originates at center line

Extend shirt

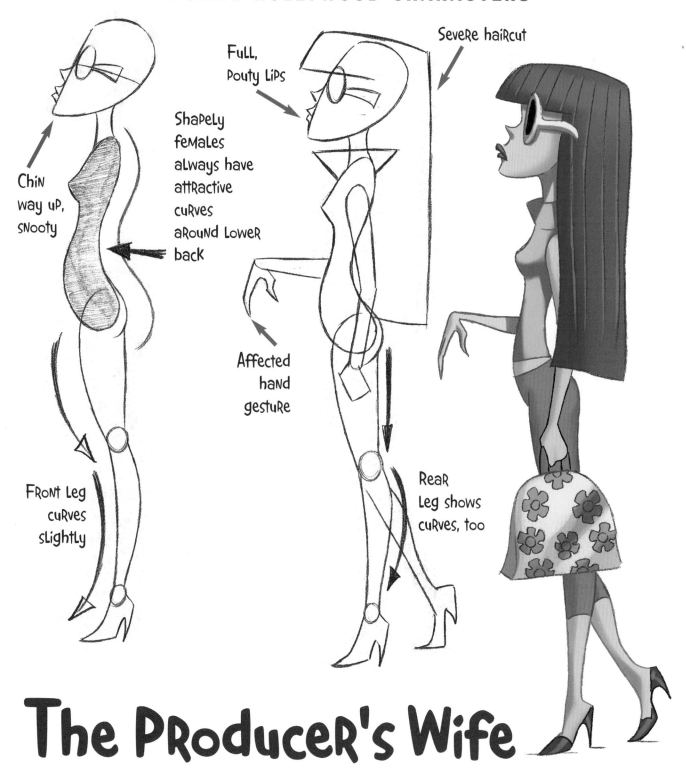

Chin way up, snooty

Shapely females always have attractive curves around lower back

Front Leg curves slightly

Full, Pouty Lips

Severe haircut

Affected hand gesture

Rear Leg shows curves, too

The Producer's Wife

You see this all over Beverly Hills: **fat 45-year-old producers** and their very **pretty, 30-something wives** (and their newborn babies who look surprisingly similar to the cabana boy).

She's got a model's figure—**a little too thin.** And she's tall—taller than her hubby. Her clothes should be **so tight** they look painted on. High heels give her a willowy look, and her up-tilted chin makes sure she looks down on everybody, **figuratively and literally.**

Her hairstyle is severe, and her haircut cost more than most people earn in a week. But hey—you gotta have your **priorities.**

Personal Manager to the Stars

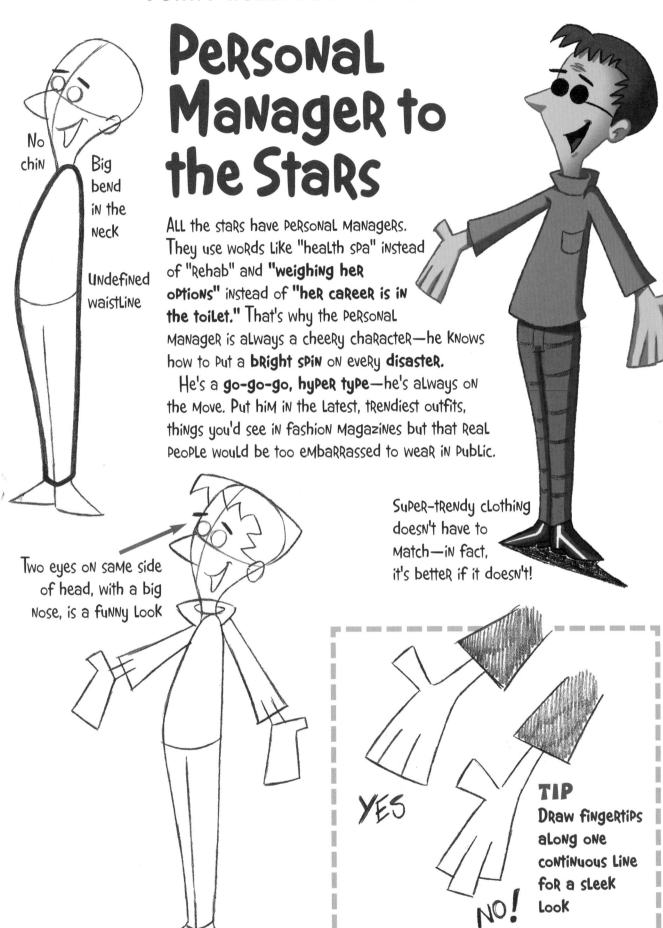

No chin

Big bend in the neck

Undefined waistline

ALL the stars have personal managers. They use words like "health spa" instead of "rehab" and **"weighing her options"** instead of **"her career is in the toilet."** That's why the personal manager is always a cheery character—he knows how to put a **bright spin** on every **disaster**.

He's a **go-go-go, hyper type**—he's always on the move. Put him in the latest, trendiest outfits, things you'd see in fashion magazines but that real people would be too embarrassed to wear in public.

Two eyes on same side of head, with a big nose, is a funny look

Super-trendy clothing doesn't have to match—in fact, it's better if it doesn't!

YES

NO!

TIP
Draw fingertips along one continuous line for a sleek look

Kid Agent

He's making deals, he's lying to clients, he's lying to studio heads—**he's an agent!** But there could be a legal problem: he's **below the minimum working age.** However, Hollywood is a youth culture, and if you're not ahead of the curve, you're behind.

This **underaged megalomaniac** is fun to draw. Watch him throw all 40 pounds of himself around, intimidate grownups who have been in the business all their lives and fire people he should respect—including, perhaps, his parents.

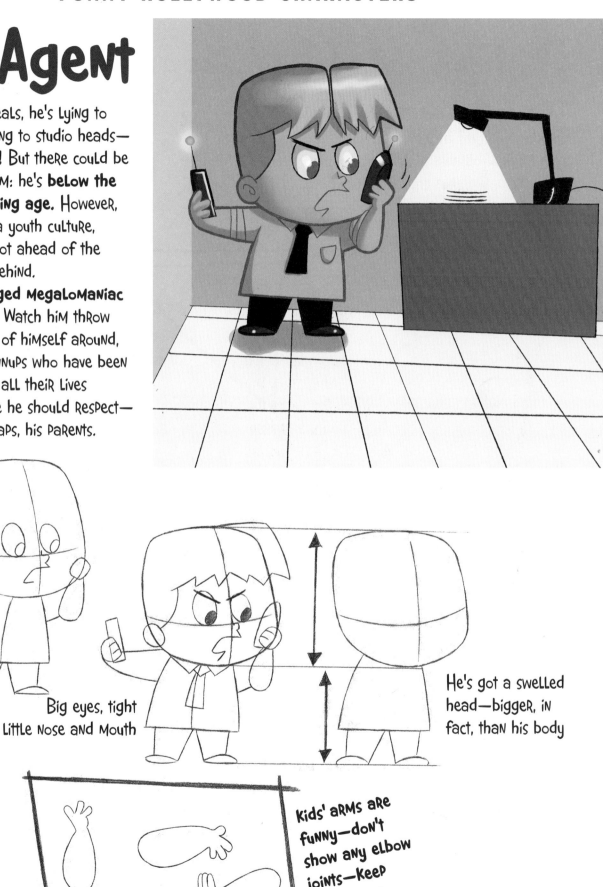

Big eyes, tight little nose and mouth

He's got a swelled head—bigger, in fact, than his body

Kids' arms are funny—don't show any elbow joints—keep them plump

Pampered Star

Everything must be done **for her.** And it must **be done right—and right away!** But she'll never tell you what right means—because it changes with the weather.

This tried-and-true character provides a good opportunity to draw a cartoon version of a female figure in front view.

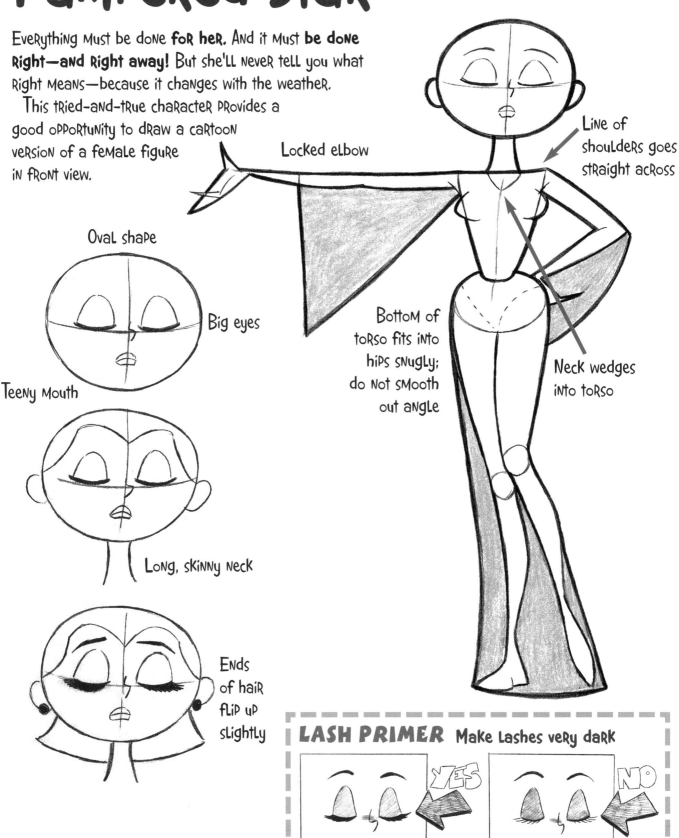

Line of shoulders goes straight across

Locked elbow

Oval shape

Big eyes

Teeny Mouth

Long, skinny neck

Ends of hair flip up slightly

Bottom of torso fits into hips snugly; do not smooth out angle

Neck wedges into torso

LASH PRIMER Make lashes very dark

YES

NO

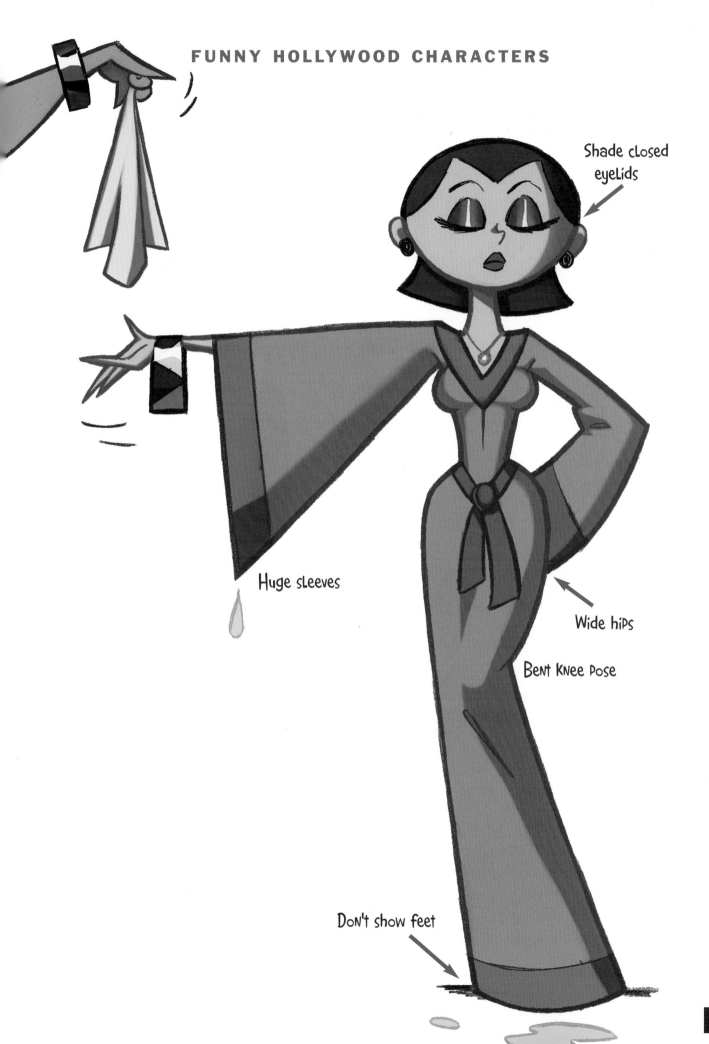

Shade closed eyelids

Huge sleeves

Wide hips

Bent knee pose

Don't show feet

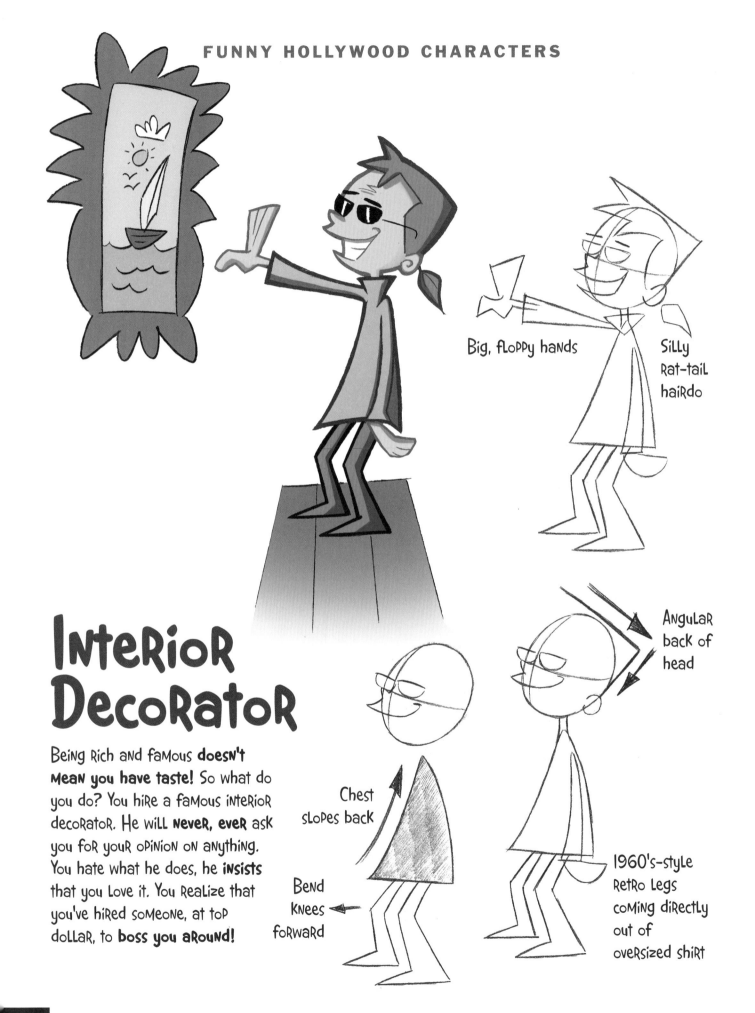

Big, floppy hands

Silly Rat-tail hairdo

Angular back of head

Chest slopes back

Bend knees forward

1960's-style retro legs coming directly out of oversized shirt

Interior Decorator

Being Rich and famous **doesn't mean you have taste!** So what do you do? You hire a famous interior decorator. He will **never, ever** ask you for your opinion on anything. You hate what he does, he **insists** that you love it. You realize that you've hired someone, at top dollar, to **boss you around!**

Police Dude

The police officers in Santa Monica, a beach town near L.A., **chase bad guys on bicycles.** Personally, I don't see how they can cuff a perp, put him on the handlebars and pedal him off to the station, but I guess things are different in L.A.

The stereotypical big-city cop is less than Adonis-like in build, but L.A. is the exception to the rule. The cops are all Nautilus-trained, with **highly developed necks, shoulders and chests.** The only thing about them that isn't developed is their sense of humor. **(Just kidding, officer!)**

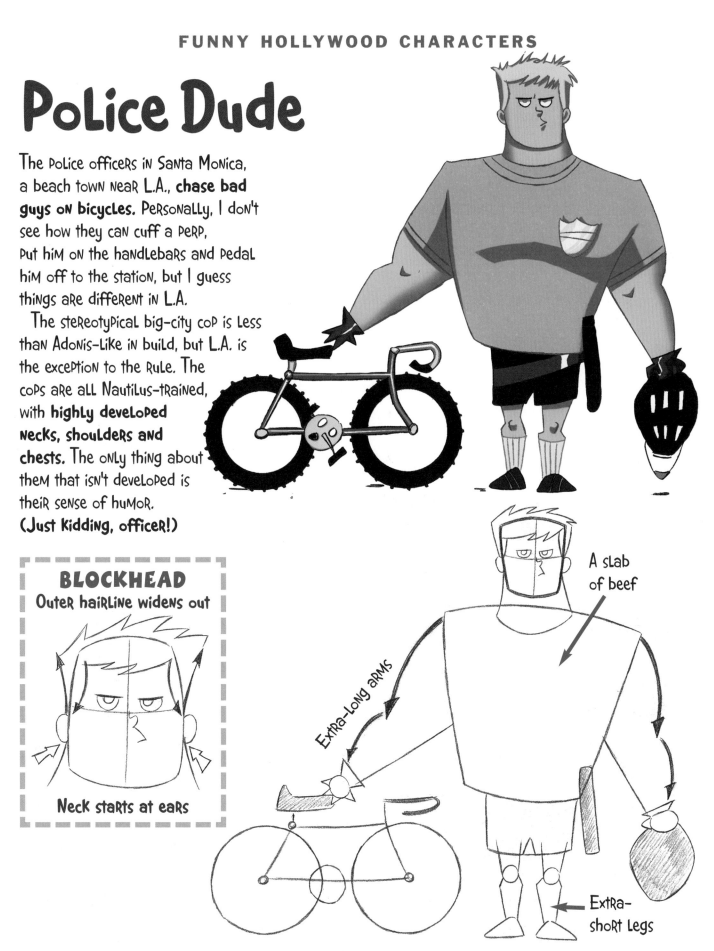

BLOCKHEAD
Outer hairline widens out

Neck starts at ears

A slab of beef

Extra-long arms

Extra-short legs

DON'T MAKE THE WAIST TOO THIN OR HE'LL LOOK LIKE A BODYBUILDER INSTEAD OF A COP

Rodeo Drive Shopper

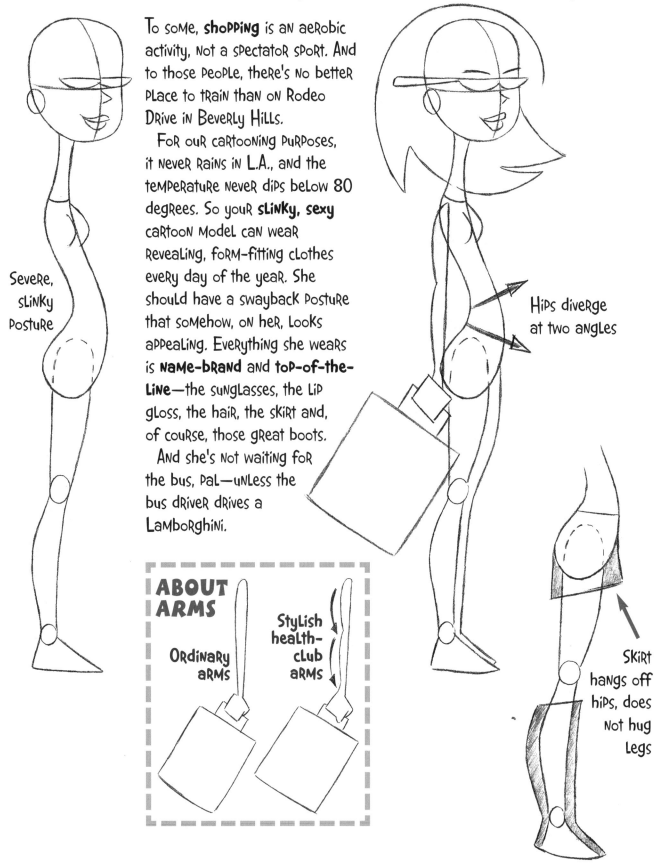

To some, **shopping** is an aerobic activity, not a spectator sport. And to those people, there's no better place to train than on Rodeo Drive in Beverly Hills.

For our cartooning purposes, it never rains in L.A., and the temperature never dips below 80 degrees. So your **slinky, sexy** cartoon model can wear revealing, form-fitting clothes every day of the year. She should have a swayback posture that somehow, on her, looks appealing. Everything she wears is **name-brand** and **top-of-the-line**—the sunglasses, the lip gloss, the hair, the skirt and, of course, those great boots.

And she's not waiting for the bus, pal—unless the bus driver drives a Lamborghini.

Severe, slinky posture

Hips diverge at two angles

Skirt hangs off hips, does not hug legs

ABOUT ARMS

Ordinary arms

Stylish health-club arms

126

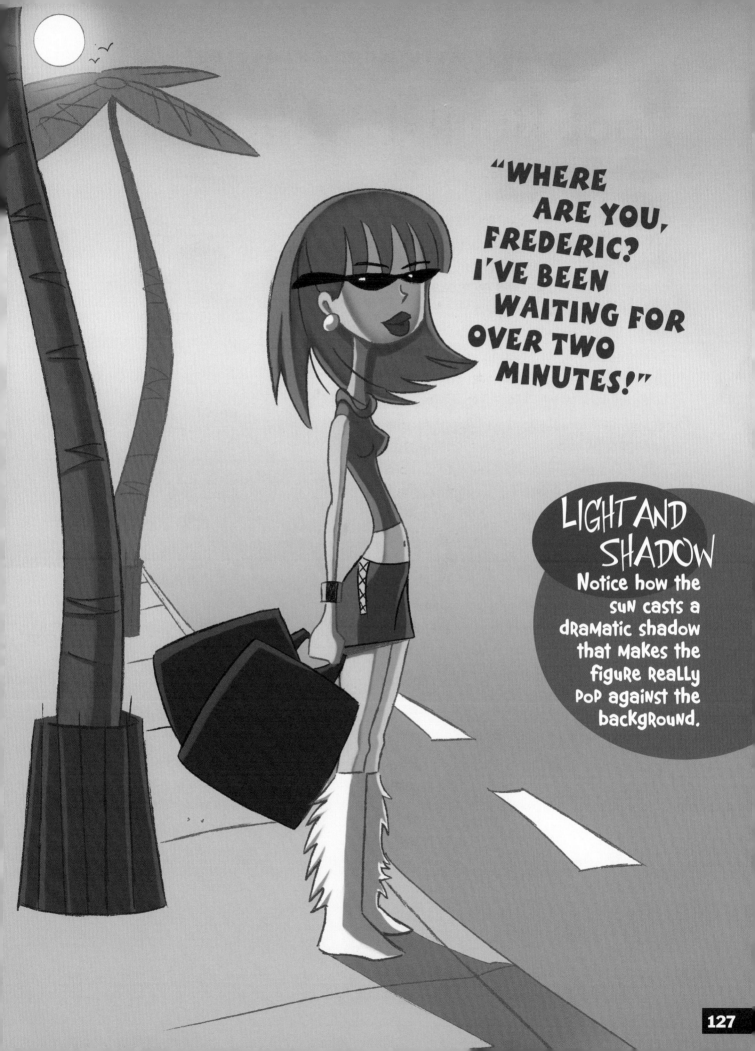

Pool Boy

Guys: Don't hire this guy to clean your pool while **you're off at work and your wife is home.** This character is a rogue with charm and an incorrigible **flirt.** He needs a swimmer's body, not a weightlifter's, and regular swimming trunks, not Speedos. His hair should be slicked back, not windblown. A pair of oversized sunglasses completes his look.

Since this guy spends all day in (at most) a bathing suit, it's time for a short anatomy refresher.

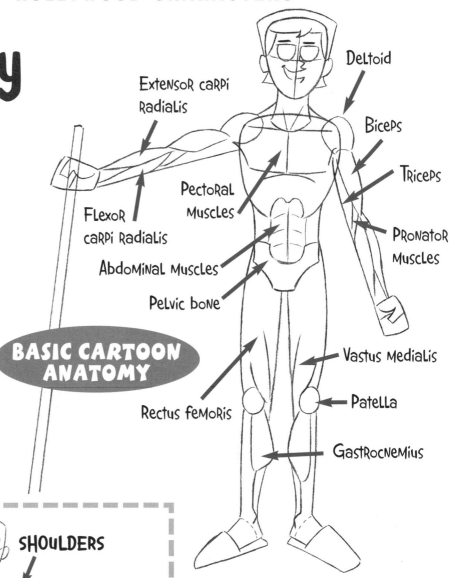

Extensor carpi Radialis

Deltoid

Biceps

Triceps

Pectoral Muscles

Flexor carpi Radialis

Pronator Muscles

Abdominal Muscles

Pelvic bone

BASIC CARTOON ANATOMY

Rectus femoris

Vastus Medialis

Patella

Gastrocnemius

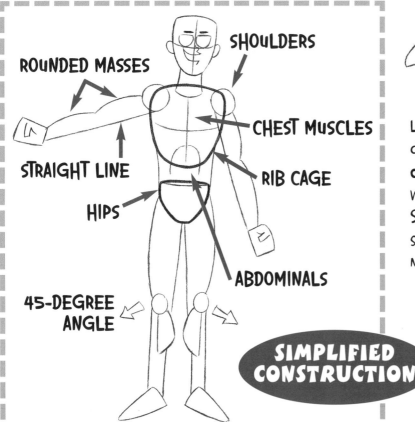

ROUNDED MASSES

SHOULDERS

STRAIGHT LINE

CHEST MUSCLES

HIPS

RIB CAGE

ABDOMINALS

45-DEGREE ANGLE

SIMPLIFIED CONSTRUCTION

Even after the anatomy lesson, we're going to draw this character with **cartoon anatomy**—in other words, not too articulated. Still, we have to have some idea of where the muscles actually go.

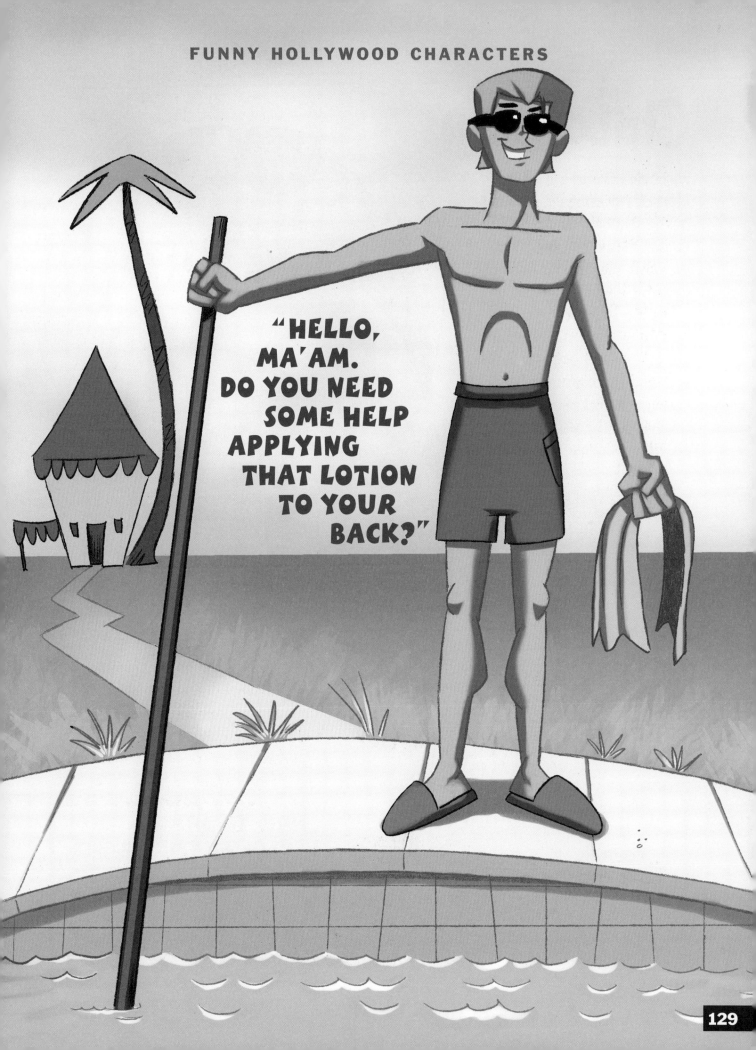

Child Star

While the cameras are rolling, she's **America's sweetheart.** But when they stop, so dies her cute act. She's the original **enfant terrible.** Whatever she wants, she gets. No amount of groveling can satisfy her ego.

Tina the Terrible is a condensed package of personality. Her eyes are so extremely expressive that her nose actually disappears. And always make her tiny. The idea of someone **so tiny** wielding **enormous power** is very funny.

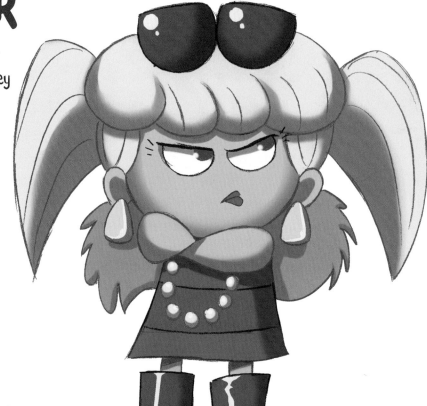

Hairstyle makes head appear extra-wide

Oversized pigtails

Tiny legs almost disappear between her skirt and boots

HOW TO DRAW FOLDED ARMS

HIGHER

LOWER

Note: the arrows do not meet!

Precious Hollywood Pooch

Any **toy dog** with a designer jacket will do the trick. I like to show little dogs **walking on their toes**—it gives them a sweet, perky attitude. Some small dogs, such as Skye terriers, have large ears, which gives them **a charming look.**

You can draw like a pro!

I've enjoyed sharing these techniques with you. I hope you keep this book among your art supplies. You can open it at any time to find hints that will help you improve your drawing skills. Thanks for visiting, and until next time, keep drawing!'

Chris Hart

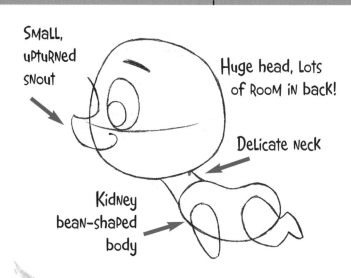

Small, upturned snout

Huge head, lots of room in back!

Delicate neck

Kidney bean-shaped body

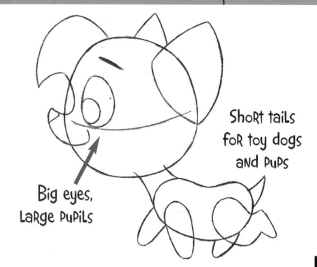

Short tails for toy dogs and pups

Big eyes, large pupils